VERMEER

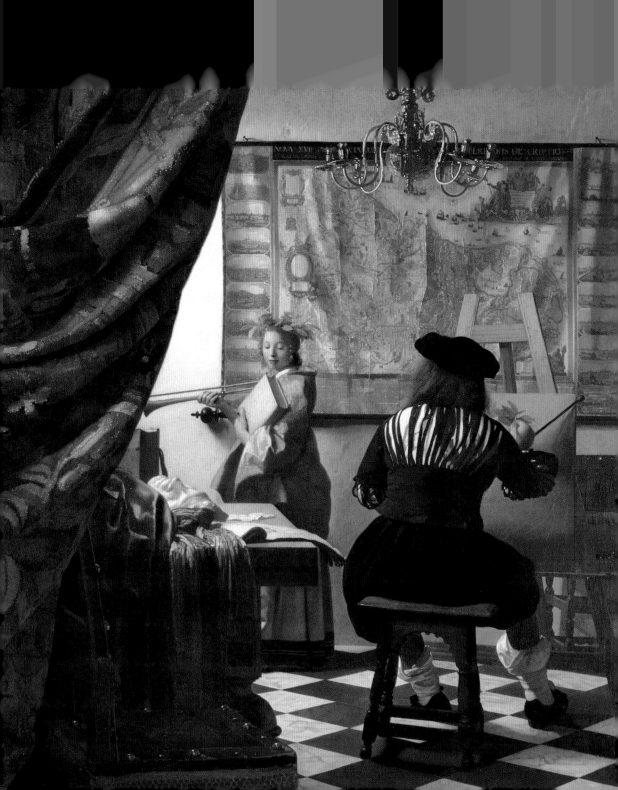

MASTERS OF ART

VERMEER

Alexander Adams

PRESTEL

Munich · London · New York

Front Cover: Johannes Vermeer, *Girl with a Pearl Earring*, c. 1664–67
(detail, see page 83)

Frontispiece: Johannes Vermeer, *The Art of Painting*, 1668? (or 1666),
Kunsthistorisches Museum, Vienna
pages 8/9: Johannes Vermeer, *View of Delft*, c. 1660/61 (detail, see page 65)
pages 38/39: Johannes Vermeer, *The Glass of Wine*, c. 1659–61 (detail, see page 59)

© Prestel Verlag, Munich · London · New York 2024
A member of Penguin Random House Verlagsgruppe GmbH
Neumarkter Strasse 28 · 81673 Munich

A CIP catalogue record for this book is available from the British Library.

Editorial direction, Prestel: Cornelia Hübler
Copyediting and proofreading: Vanessa Magson-Mann, So to Speak, Icking
Production management: Martina Effaga
Design: Florian Frohnholzer, Sofarobotnik
Typesetting: ew print & media service gmbh
Separations: Reproline mediateam
Printing and binding: Pixartprinting, Lavis
Typeface: Cera Pro
Paper: 150 g/m² Profisilk

Penguin Random House Verlagsgruppe FSC® N001967

Printed in Italy

ISBN 978-3-7913-7730-8

www.prestel.com

CONTENTS

INTRODUCTION

Public love for, and critical appreciation of the paintings of Johannes Vermeer (1632–1675) have never been greater. A landmark 2023 Vermeer exhibition at the Rijksmuseum, Amsterdam (which included twenty-eight paintings attributed to Vermeer—an unprecedented gathering) broke attendance records, as did a documentary film about that event. A wave of monographs, novels, films, television documentaries and secondary media has spread Vermeer's fame worldwide over recent decades. In multiple polls, Vermeer ranks in the top five most popular artists. During a Vermeer exhibition in Washington D.C. in 1995, altercations broke out among those struggling to enter the exhibition, attendance of which had been congested by visitors lingering longer than had been anticipated.

Yet in 1850 even learned art historians had not heard of Vermeer. How is such a meteoric rise from obscurity possible? No artist's reputation has experienced a more dazzling revival than Vermeer's, whose small body of paintings was—for almost two centuries—overlooked or mingled into the corpuses of more esteemed painters. There can be few painters who, once having reached maturity, painted so many masterpieces. Their range is limited, but the constricted nature of the selected artistic field—single figures or two figures paired in domestic interiors—allowed the painter to bring his vision to perfection, for (in the Western oil painting tradition) no art better deserves the epithet "perfect" more than that of Vermeer. The few discordant pictures produced by the artist demonstrate how carefully balanced and executed his successful paintings are. This book will try to answer why Vermeer is so supremely good and why he appeals to us so much.

Vermeer is one of the most elusive of the great artists, even more than Piero della Francesca and Giorgione, painters of an earlier age. It was not without reason that the critic who popularised him called Vermeer "The Sphinx of Delft". We have no drawings from Vermeer's hand; nor do we have any letter or contract written by him; there is no confirmed portrait likeness of the artist. There are no memoirs or letters attesting to Vermeer's appearance or character; consequently, most of what we know of the man Johannes Vermeer is inferred from his subtle, almost inscrutable, art.

Although the body of his work has been stable for about a century, and there has not been a generally agreed addition to that body since 1969, new information has been forthcoming. Imaging technology, radiography and pigment analysis has

advanced rapidly and revealed much about how Vermeer painted as well as the painstaking lengths he undertook to perfect his pictures. Technology has allowed us to discover elements only previous seen by the artist before he painted over them. We have scientific proof that later hands added objects and backgrounds after the paintings had left the studio; in some cases, these interventions have been reversed, restoring Vermeer's original paintings. Restoration of *Woman Reading a Letter at an Open Window* dramatically altered its appearance and has transformed our understanding of it. Additionally, cleaning has revealed details formerly obscured by layers of discoloured varnish.

Archive research has provided tantalising glimpses of Vermeer's world—the circumstances of his in-laws, Catholic institutions he would have known well, patrons who bought pictures—even if it does not show us the whole man. Paintings and maps (or versions of them, at least) that appear in Vermeer's pictures have been identified. While it seems very probable that we shall never find a portrait of the artist nor a document by his hand—and it seems just as likely that no lost Vermeer paintings will be brought to light—studies by specialists add almost yearly to our understanding of one of Western art's most astonishing geniuses. That research will be presented here in summarised form.

At a time when high-quality digital imaging technology, radiography and paint analysis reveal more of a painting than is apparent to the naked eye, we do well to remind ourselves that what is above all important about a work of art is what was left to us. To concentrate upon how a painting was made or how it changed during creation is much less significant than what is visible. What is most important is what we have—what the artist chose to bequeath us—not how it came to be. It is breathtaking subtlety, rigorous observation, relentless invention and humane compassion that mark out Vermeer as worthy of veneration, study and emulation.

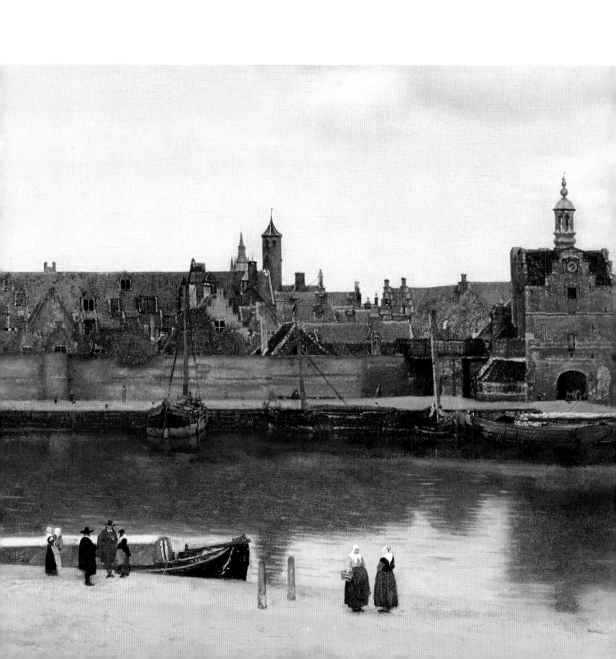

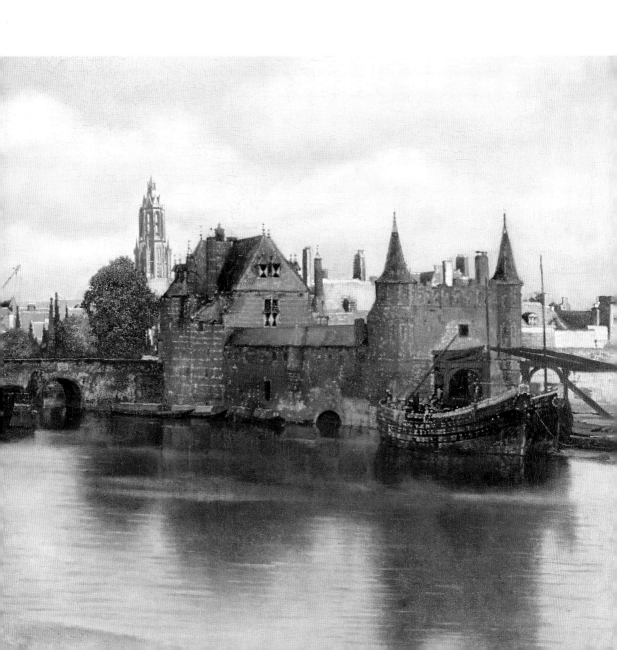

On 31 October 1632, at the Nieuwe Kerk in Delft, the child of a local couple was christened. There was no indication then that this child of a humble family, baptised "Johannis Vermeer", would ultimately be linked so closely to the fame of his home city. His mother was Digna Baltens (c. 1595–1670) and his father Reynier Jansz. Vos, later "Vermeer" (c. 1591–1652); he was Delft-born and had lived in Amsterdam, employed as a skilled cloth worker. He returned to Delft with his wife to become an innkeeper and dealer in pictures. It was in that latter capacity that Vermeer senior joined the Delft Guild of Saint Luke in 1631. In 1641 the family bought a large inn, called the "Mechelen", in the centre of the city. Young Johannes, the couple's only son, would grow up in an inn-cum-shop, surrounded by mostly Dutch and Flemish art.

During the seventeenth century the city of Delft, positioned between the major coastal port of Rotterdam and the court city of The Hague, was an important centre of industry and defence. It was in the southern part of the United Provinces of the Netherlands, Protestant territory which had separated from the Catholic Habsburg Empire in 1581 during a protracted war of independence (which lasted from 1568 to 1648). During the Dutch Golden Age, the production of beer, cloth and (most famously) pottery decorated in blue and white (called Delftware), as well as the import of woollen cloth from England, all served to make Delft an affluent city. To this was added the countrywide influx of wealth due to the Dutch mercantile network, including the Verenigde Oost-Indische Compagnie (Dutch East India Company), founded in 1602. Although the city was an inland port rather than a coastal one, barge-carried cargo made

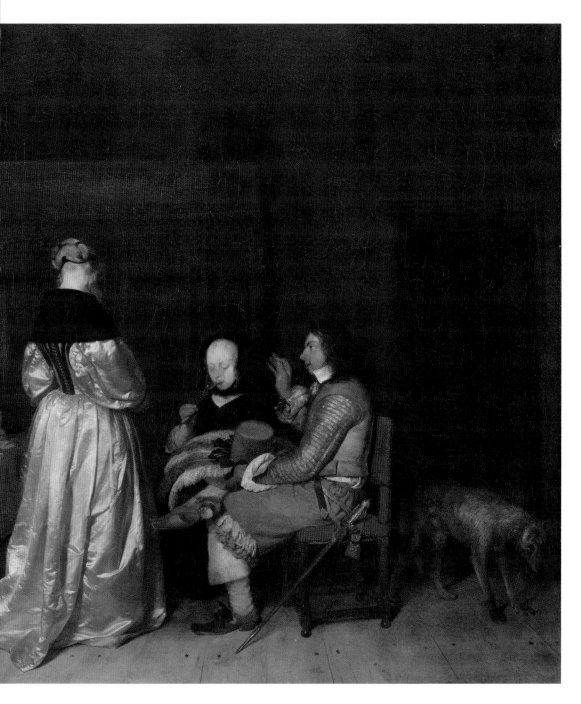

city residents prosperous enough to sustain resident producers of decorative luxuries, such as furniture, glassware, silverware, tapestries, sculpture, prints and paintings. In 1624, the population of Delft was 21,000, larger than The Hague (18,000 residents); however royal patronage meant artistic pre-eminence belonged to artists of The Hague. By 1650, Delft had a population of about 24,000 people growing to 25,000 by 1670.

A lost apprenticeship

Starting in the 1640s, Vermeer would have undergone his painter's apprenticeship, which in the Netherlands of this era usually lasted nine years. Its location, the name of his master, the nature of any journeys undertaken and the character of his earliest paintings are all completely unknown to us. Amsterdam and Utrecht have been suggested as potential places for his apprenticeship, each being cities with flourishing studios which might have trained Vermeer. Due to his originality—for example, he used terre verde (green earth) on the faces of a figure, a rare approach in Dutch painting of the period—more than one historian has suggested that his individuality (and the apparent absence of the expected records or commentary regarding his training) indicates that Vermeer may not indeed have had a master. Instead, it is hypothesised that he taught himself by looking at art, talking to painters, copying and using a *camera obscura*.

The *camera obscura* (literally "dark room" in Latin) is a form of pinhole camera, where light entering a darkened space through a small hole is projected against a surface; this is sometimes refined by the use of a lens or mirror to focus and isolate images. The projected forms take on the appearance of a slide projection and their outlines may be transcribed with an implement. When observed at length and correctly recorded, they may form the basis for a painting or drawing. A *camera obscura* can be made as large as a room or as small as a portable wooden case with a glass lens. This principle is also to be found in the *camera lucida* ("lighted room"), a device which casts a reflection on a surface in daylight, without the need for a darkened space.

Vermeer certainly studied the effects of lenses and would have heard artists discussing the advantages (and drawbacks) of these devices. We know that Carel Fabritius (1622–1654)—pupil of Rembrandt and an artist respected by Vermeer—made at least one painting using a distorting lens, which was housed in a viewing cabinet. Some effects found in Vermeer's paintings replicate those of lens projections, namely the halation effect (glow of light), blurring, dotted highlights and compression of pictorial depth caused by magnification of objects close to the lens. Whether Vermeer did use a *camera obscura* or *lucida* is a matter upon which experts disagree. We can say with certainty that Vermeer was familiar with the *camera obscura*. He deployed varied techniques, constantly adjusting pictures, even at states that might otherwise have been considered final. The theory he used lenses as part of his self-training is undermined by the fact that the earliest known paintings of Vermeer are perfectly comprehensible as products of a painter trained by an artist of an earlier generation using conventional methods; these show no influence of lens-generated effects.

Reynier Jansz. Vermeer died (indebted) in October 1652 and his widow took over the running of the Mechelen, which had apparently become a burden to the family. Six months later, on 20 April 1653, Vermeer married his bride Catharina Bolnes (c. 1631–1688), daughter of Maria Thins (c. 1593–1680), a local property owner, and the brick-manufacturer Reynier Bolnes (1591–1674). The bride's family were Catholic and just prior to his wedding Vermeer converted from Protestantism to Catholicism. Maria Thins invited the young couple to share her house on De Oude Langendijk; the bride was soon pregnant with the first of at least eleven children. As well as attending the Catholic church, Maria Thins was associated with the local Jesuit centre, located in the Catholic district of Delft where she lived (the so-called "Papists' corner"). Recent research tells us the Jesuits considered the *camera obscura* to be a machine with spiritual connotations.

That Vermeer sometimes struggled financially is attested to by a number of loans he took out, including some from his mother-law, who had become wealthy through inheritance. As well as owning property outside of Delft, she possessed art, including original paintings by (or copies of) Dirck van Baburen, *The Procuress* (page 18) and

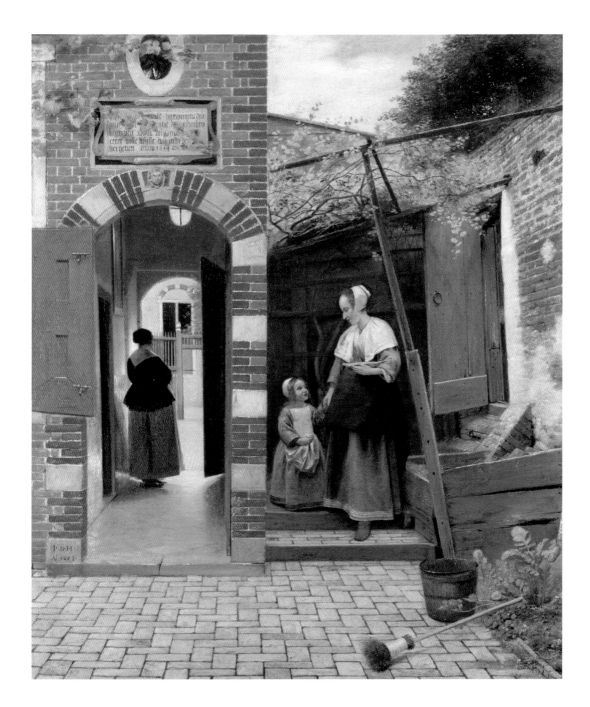

Although we know some paintings are lost, it has been estimated that his lifetime production may have been around only fifty paintings

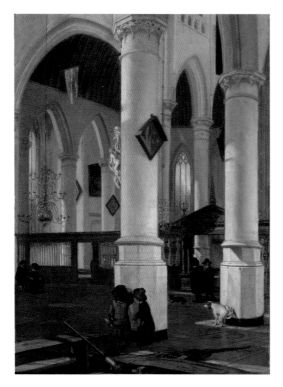

Emanuel de Witte, *Interior of the Oude Kerk, Delft*, c. 1650

Cimon and Pero (*Caritas Romano*), c. 1622–24, and Jacques Jordaens, *The Crucifixion of Christ* (page 36). This art was incorporated into Vermeer's paintings. *The Procuress* appeared in Vermeer's *The Concert* (page 69) and *Young Woman Seated at a Virginal* (page 109); *The*

Crucifixion of Christ appears in *Allegory of the Catholic Faith* (page 107).

Vermeer enrolled in the Delft Guild of Saint Luke on 29 December 1653, becoming a full member; his fees were not paid off completely until December 1656. He managed to pay this amount and clear his father's debts probably after taking out a loan from a wealthy burgher, Pieter Claesz. van Ruijven, who would become his patron. Despite Vermeer's debts, he was obviously held in good standing, as he was appointed to serve four years as headsman of the guild.

By the middle of the seventeenth century, the Delft School had become a centre for realism, superseding the art of the Haarlem School. Painting styles came and went in distinctive waves—ones that can be dated precisely due to the clothing, hair and furniture depicted. When it comes to reconstructing Vermeer's development, we rely upon the evolution of his style and signature in relation to the four (or possibly five) paintings he dated. Therefore the chronology of Vermeer's art is speculative. This book largely follows two authoritative sources regarding dating: Professor Arthur K. Wheelock and cataloguers of the 2023 Rijksmuseum exhibition, whose opinions sometimes diverge; when I differ from them, explanation is provided.

On the morning of 12 October 1654, the municipal gunpowder depot, the so-called "Secret of Holland" exploded. The storehouse contained around 90,000 pounds (40,000 kilograms) of gunpowder. The explosion was colossal, destroying many buildings and killing hundreds of people

Pieter de Hooch, *Interior with a Woman Weighing Gold Coin*, 1664

(including Fabritius). The *Delftsche Donderslag* (Delft Thunderclap), as it came to be known, was a defining event in Delft for those who lived through it. Dignitaries and mere sightseers came to the city to witness the devastation, which was recorded by local artists.

In the company of painters

When we think of the loose network of painter colleagues—masters, students and fellow guild members—within which Vermeer worked, we must consider certain prominent artists. These include Gerard Ter Borch (1617–1681, working in Deventer and Amsterdam, pages 11 and 27), Jan Steen (c. 1625–1679, Delft), Pieter de Hooch (1629–after 1684, Delft, pages 15 and 17) and three students of Rembrandt, namely Fabritius (of Amsterdam and Delft, page 21), Nicolaes Maes (1632–1693, Amsterdam and Dordrecht), and Gerrit Dou (1613–1675, Amsterdam and Leiden), the latter who trained Frans van Mieris the Elder (1635–1681, Leiden) and Gabriël Metsu (1629–1675, Leiden and Amsterdam, page 23). These are in addition to the Delft painters of church interiors (including Emanuel de Witte, c. 1617–1692, page 16) who emerged during Vermeer's youth. We can also add Samuel van Hoogstraten (1627–1678, Dordrecht), whose painting *The Slippers* (page 31), was painted at the same time as Vermeer's *A Maid Asleep* (page 49), another picture of a view through interior doorways.

Two *tronien* (character heads) by Fabritius were owned by Vermeer at the time of the latter's death. The exact relationships between Vermeer and the painters listed above is a matter of conjecture, although there would have been transmission of technical knowledge and aesthetic ideas, not least through Vermeer's roles in the guild. We surmise that Ter Borch probably travelled from Amsterdam to Delft in order to attend Vermeer's wedding, as he co-signed a legal document with Vermeer a few days later. It is clear Vermeer learned lessons from the work of colleagues and that some of them adapted their art to incorporate Vermeer's subdued mood and indirect narratives. Although Vermeer is now more famous than his colleagues, we should not assume that he was the most original of them. In fact, comparative examination reveals Vermeer perfected innovations of fellow artists, using his extreme sensitivity and diligence to make his art more remarkable than theirs. This perfectionism is one reason why Vermeer's output is so low. Although we know some paintings are lost, it has been estimated that his lifetime production may have been around only fifty paintings. He had no known pupils, not just because he had insufficient work to give them but also because he knew that the quality of his painting would be diminished by contributions from less competent hands. However, the issue has recently become controversial again, due to debates over the authenticity of two paintings which will be discussed later.

Once he had mastered genre painting, Vermeer took his goal to be (with or without the *camera obscura*) the conjugation of appearances through

Johannes Vermeer, *View of Houses in Delft (The Little Street)*, c. 1658/59 (detail, full picture see page 55)

light effects rather than describing objects. To do this, Vermeer disregarded what he already understood about objects and found new ways of summarising what he saw. For example, in *The Little Street* (page 55) instead of describing each cobblestone (or a few individual cobblestones), Vermeer evokes rows of stones by way of wavering

lines. Vermeer suggests rather than documents, depending on the viewer's capacity for inference, and develops that visual shorthand by taking a lead from light rather than depending upon his empirical understanding of the items depicted.

We can see a steady development in Vermeer's thinking. Early multi-figure genre scenes are reduced to either single or two figures at most in interiors, which are set in particular rooms. A small array of domestic items act as props, while paintings by others serve as pictorial elements to be arranged as carefully as if they were objects in a still-life. We value the impression of stillness and tranquillity. Even though Vermeer lived in a house filled with the noisy activity of children, this does not appear in his art. The mature Vermeer does not push us towards judgement, and this detachment—his moral inscrutability—also accords with the tastes of the majority of Western art viewers today. Narrative ambiguity and lack of didacticism appeals to the modern sensibility, averse to direct moral instruction and unversed in (even resistant towards) symbolism.

French diplomat and diarist Balthasar de Monconys visited Delft in the summer of 1663. He had heard that Vermeer was a notable painter but, when he visited his studio, Vermeer had apparently no pictures to show. Monconys was directed to the baker Heinrick van Buyten, who showed him a Vermeer painting of a single figure, for which van Buyten had paid the high sum of 600 livres. Monconys considered the amount excessive. That price was the same as that for a similar painting by Gerrit Dou.

A new Phoenix

Vermeer's high standing as an artist in Delft was demonstrated not only by the high prices his works fetched but also because of his appointment as headsman of the Guild of St Luke. He had been elected in 1662; it was a post he held again in 1670 and 1671. This attests to the high regard he was held in, also a measure of his probity and diligence. In 1667 a poem lauding Fabritius was published by the printer and publisher Arnold Bon (before 1634–1691), which included mention of Vermeer, then 35 years old.

> Thus expired this Phoenix [Fabritius] to our loss,
> In the midst and in the best of his powers,
> But happily there arose from his fire
> Vermeer, who masterfully emulated him.

It was at this time that Vermeer was working on his masterpiece *The Art of Painting* (page 93). Had Bon seen that painting in his studio before writing this praise? Had Vermeer told Bon that he admired Fabritius above all other Dutch painters or even that he had been Fabritius's pupil?

The apparent lack of underdrawing on the paintings, as assessed through imaging technology, has led to speculation about Vermeer's technique. Clearly, he did not transfer preparatory drawings to a primed canvas before painting, but we should not interpret the absence of Vermeer drawings as evidence that he did not draw. Experts note that few drawings of genre scenes by Delft artists exist, so it is feasible that such drawings were

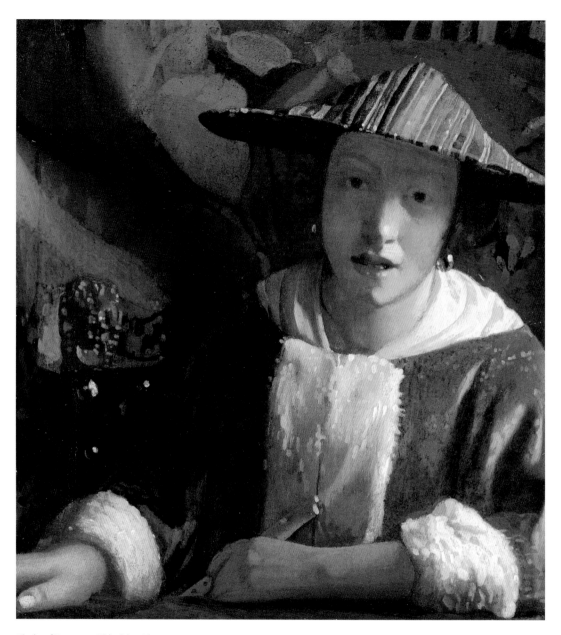

Circle of Vermeer, *Girl with a Flute*, c. 1664–67

Many questions arise from the reduced production of Vermeer's last years

once existent and have since been discarded or were destroyed by the artist, as commonly happened. As the artist did not have apprentices that we know of, he had no followers who might have preserved such drawings. We also know that Vermeer made major changes to paintings in progress, so detailed drawings may not have been sufficiently worthwhile in that process.

Pinholes for string chalk have been detected in at least thirteen Vermeer paintings. These indicate where the painter situated perspective points, sometimes multiple ones on the same paintings. From these pins, the artist stretched threads covered with dry pigment. When snapped against the surface, they left perspective lines of dust the painter could use as guidelines. This undermines the assertions that Vermeer depended upon the *camera obscura*. For, if Vermeer was tracing projections of light, why would he need perspective lines derived from a pin and thread? Major alterations to the paintings while in progress suggest that Vermeer did not need to draw detailed compositional sketches. Considering what facts we have to hand (use of pins, pentimenti, optical artefacts) we can conclude that Vermeer was a remarkably flexible and ingenious painter, who deployed a variety of approaches, adapting as necessary to produce the best paintings that he could.

In May 1672, Vermeer was one of the painters and dealers summoned to The Hague to appraise a collection of Italian paintings and sculptures. This was part of a dispute over the valuation of items acquired by Frederick William, Elector of Brandenburg, only to be subsequently returned to the vendor as unsatisfactory. Vermeer was scathing about the low quality of the art, finding it wildly overvalued. The Delft Guild of Saint Luke successfully restricted the import of paintings, guarding the trade in new paintings to guild members only. This incident tells us that Vermeer must have acquired his knowledge of Italian art from time spent in Amsterdam or further afield.

Patrons and purchasers

John Michael Montias, a leading Vermeer researcher who located and republished original records, calculates that Vermeer earned between 200 and 600 florins per year (until the *rampjaar*, discussed later), producing two to three paintings in that period of time. (Leading to the previously mentioned estimated lifetime output of between forty-four and fifty-four paintings, of which thirty-five indisputably authenticated paintings survive.) Rather than painting pictures that had to appeal to the general market, Vermeer was able to

produce his work in a deliberate and slow manner due to the patronage of Pieter Claesz. van Ruijven (1624–1674), the burgher and inheritor of a brewing fortune, and his wife Maria de Knuijt (1623–1681). The patronage is thought to have started around 1657. The couple came to own twenty Vermeer pictures during the artist's lifetime and Maria named Vermeer as a beneficiary to her will, although she in fact went on to outlive the artist. Maria knew the Vermeer family, as she had grown up close to the Mechelen inn and must have seen Vermeer and his sister when they were young. We know of a few others who bought paintings directly from Vermeer. In addition to the van Ruijvens and the baker van Buyten, there were Johan (Jean) Larson (English sculptor), Johannes de Renialme (art dealer), Nicholas van Assendelft (alderman) and perhaps several more distinguished figures. All of them lived in Delft.

When Pieter died in August 1674, his widow inherited the Vermeer paintings, but there may have been an interruption in payments because by 20 July 1675 the artist was in Amsterdam, borrowing 1000 guilders from a merchant. The security Vermeer offered in return for the loan was not his to give, which indicates the family was in financial distress by this time. This came after loans of 800 florins which had been taken out two

years earlier. The Vermeer family had accrued substantial debts with tradesmen that not even these loans (and annual payments from Maria Thins to her son-in-law) could cover. Adding to the burden was the responsibility for the Mechelen inn, which had passed to the artist upon the death of his only sibling, his sister Geertruijt, in May 1670.

Many questions arise from the reduced production of Vermeer's last years. His output and circumstances were disastrously affected by the *rampjaar* ("disaster year"). The Third Anglo-Dutch War (1672–74) was a catastrophe for the Dutch nation; it entered into conflict with England and France (allied to Cologne and Munster) leading to a naval blockade, civil unrest and economic insecurity. The reduced demand for paintings—or at least new paintings at the prices they had recently commanded—put some artists out of business, as it did makers of other luxury goods. The *rampjaar* pushed Vermeer even deeper into debt; we know he took out ever more loans. Perhaps it forced him to stop painting and seek other income. Did he accept pupils because he needed fees? Was the commission to paint *Allegory of the Catholic Faith* (page 107) the result of a Catholic acquaintance seeking to help out the Catholic Vermeer family during the *rampjaar*? His wife testified that Vermeer was unable to sell his art

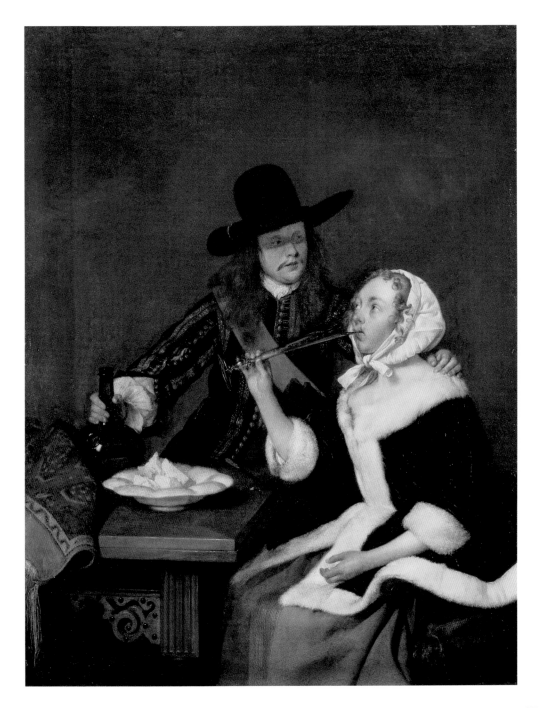

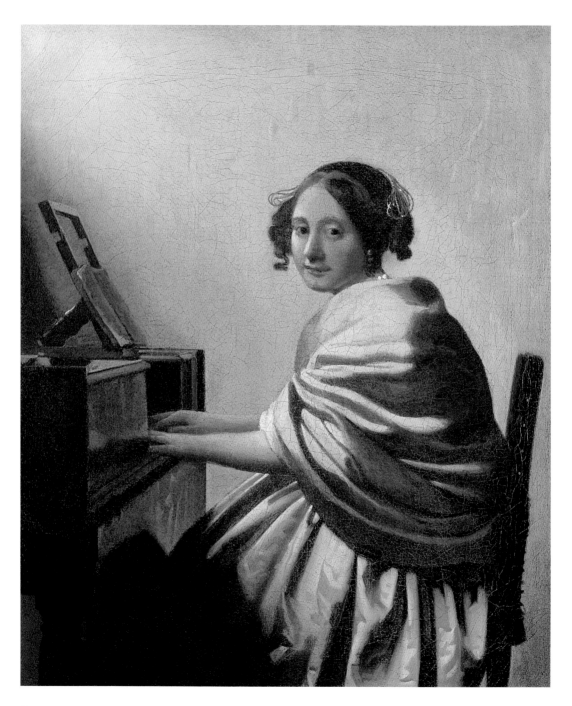

Circle of Vermeer,
Young Woman Seated at a Virginal, c. 1670–72

and paintings by others due to the war and that "the very great burden of [his] children, having nothing of his own, he had lapsed into such decay and decadence, which he had so taken to heart, as if he had fallen into a frenzy, in a day and a half he had gone from being healthy to being dead." She attributes the painter's sudden death to the pressures of debt and the necessity of providing for his large family. Johannes Vermeer died in December 1675 and was buried (next to one of his children) on 16 December 1675 at the Oude Kerk, Delft.

Vermeer's widow, Catharina, exaggerated her poverty in an attempt to deter creditors from pursuing her too aggressively. There were a few paintings made by Vermeer that were in his own possession at the time of his death, including *Woman Writing a Letter with her Maid* (page 105), *The Guitar Player* (page 101) and *The Art of Painting* (page 93). The ownership of the latter was switched to his mother-in-law in order to preserve it from the creditors' court. Whatever the exact circumstances of the family's finances, it was clear that debts had mounted. The family owed the baker 617 florins; a debt which was cleared in return for two Vermeer paintings. Catharina sold (for 500 florins) twenty-six paintings Vermeer owned, seemingly at a loss, as well as ten lengths of painting linen and six unused panels.

Two disputed attributions

This leads us to consider the two most contentious attributions in the Vermeer corpus: *Young Woman Seated at a Virginal* and *Girl with a Flute* (page 24). As Catharina needed to liquidate what she could, she would likely have sold any unfinished paintings to the trade, which would have completed the pictures and sold them on. This might explain the awkward anomaly of *Young Woman Seated at a Virginal*, painted on canvas from the same bolt of cloth as that of *The Lacemaker* (page 89). In some ways it is a clumsy pastiche, incorporating elements from authentic paintings. The arms and wrists are distractingly wooden. The face is not composed of observed light but laboriously built, like a crude clay model. The yellow shawl is less convincing than any piece of drapery painted by the mature Vermeer. The wall is devoid of the attentive execution we might expect. However, it is on canvas that Vermeer owned and it contains pigments found in authentic Vermeers. While Wheelock, who once doubted the work, thinks it is mostly authentic, others doubt its attribution. Assessed on quality, the final painting is either largely or wholly by an inferior artist.

Jan Coelenbier (c. 1610–1677), a landscape painter and art dealer from Haarlem, acquired paintings and materials sold by Vermeer's widow. Did he buy an unfinished *Young Woman*

Seated at a Virginal and *Girl with a Flute,* which he completed himself or was the maker of these someone closer to home? In the book *Vermeer's Family Secrets* (2009), Benjamin Binstock suggests that technical and stylistic inconsistencies in some paintings could be due to the work of Maria Vermeer who (he claims) had been trained by her father and actively contributed to his art; however, Maria was never enrolled in the guild nor was she known to have painted.

Did Maria contribute to the problematic *Girl with a Flute*? Use of green earth in the face and dot highlights are consistent with Vermeer's painting but the coarseness of the paint and roughness of application are contrary to his practice. The impossibility of the fabric pattern on such a conical hat, the sloppy flute design, awkward hand anatomy and lack of a signature all tilt the balance against Vermeer's authorship. The condition of the surface, damaged through overcleaning and restoration, makes assessment difficult. Expert consideration by the National Gallery of Art led to the conclusion in 2022 that "*Girl with a Flute* demonstrates an awareness of Vermeer's idiosyncratic painting processes—such as the use of certain unusual pigments and the distinctive application of highlights—but a lack of skill or experience in reproducing them." The conclusion is that it was made by a studio associate of Vermeer, perhaps under his direction, but not by his hand. That is a view with which this author concurs. There is no strong evidence that Maria Vermeer was a painter and Binstock's thesis must be treated with caution.

Posthumous reception

Scarcity of Vermeer paintings and an absence of pupils to extend his legacy posthumously meant that his reputation fell from prominence, although auction cataloguers praised individual paintings. The death of Vermeer coincided with a rapid and permanent decline in the fortunes of his home city. Its population contracted to pre-Golden Age levels and there was little money for the expansion and renovation of properties, thereby freezing Delft for centuries in its seventeenth-century state. The fact that many buildings Vermeer knew still stand is the result of Delft's economic stagnation and demographic slump. Although Vermeer was never completely forgotten by connoisseurs, his paintings were sometimes mixed up with those of his namesakes Johannes (Jan) van der Meer (of Utrecht) and Jan van der Meer the Elder (of Haarlem), as well as with Pieter de Hooch and others. This was due to a lack of documentation and a commercial imperative which tends to aggregate paintings of uncertain attribution to more famous (and more saleable) artists.

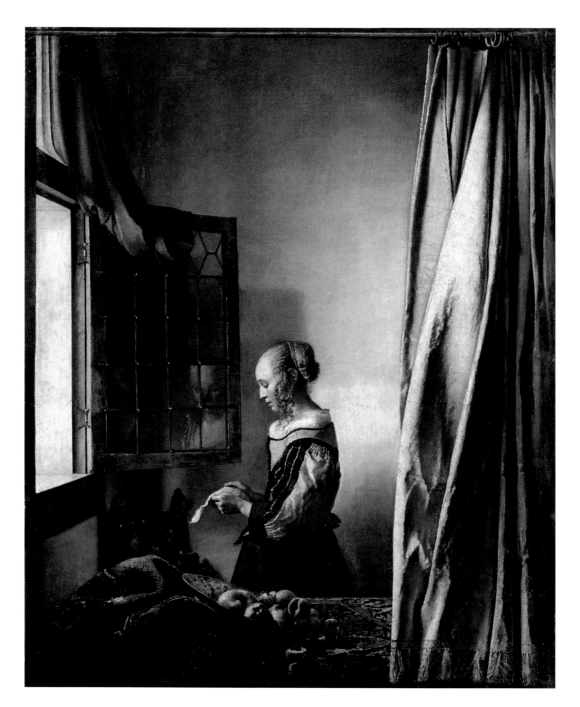

Johannes Vermeer,
Girl Reading a Letter at an Open Window, c. 1657/58
(Condition before restauration of 2017–21, see pages 50/51)

In 1866, in the *Gazette des Beaux-Arts*, French art critic Étienne-Joseph-Théophile Thoré (1807–1869)— writing as "Théophile Thoré Bürger"—published the first articles about Vermeer. These were later collected in a separate book that formed the first overview of the artist. Despite many years of research and travelling to personally inspect paintings, Thoré-Bürger's assessments were sometimes inaccurate. He built up a collection of purported Vermeers, many of which have since been assigned to other artists. Mixed into Thoré-Bürger's account of Vermeer's output were pictures by de Hooch and Jacobus Vrel (active c. 1654–62), a shadowy figure, about whose existence we know nothing. Thoré-Bürger's *catalogue raisonné* of Vermeer included genres scenes, portraits and landscapes that do not convince experts today.

Vermeer was reappraised as a master of distinction, whose paintings all informed art lovers should appreciate. The rediscovery of Vermeer and his rise to popular acclaim from the 1870s onwards is attributable to certain characteristics. Firstly, Vermeer's paintings were often compared to photography, especially because of the compression of depth and lens-generated optical artefacts apparent within them. It is in the context of the mania for photography that Vermeer's art was first championed, although admiration for other qualities in his art soon broadened appreciation. Secondly, use of optical effects in Vermeer's techniques appealed to vanguard tastemakers who had come to appreciate such qualities in Impressionist painting. Thirdly, Vermeer's precision met a liking for exactitude that had been stimulated by waves of recent art made by the Pre-Raphaelites (such as John Everett Millais, 1829–1896), the Orientalists (such as Jean-Léon Gérôme, 1824–1904) and pompier painters (such as Ernest Meissonier, 1815–1891). Vermeer met those standards without the fussy detail that can sap liveliness from nineteenth-century painting.

Lastly, as a reaction against the didactic purpose of art during the Victorian era, Vermeer's paintings possessed a moral opacity and narrative ambiguity with which people felt comfortable. The overt moralising of Dutch genre paintings had been collected and widely reproduced in the nineteenth century, but for aesthetes and those who considered themselves above the bawdiness and drollery in moral scenes of ordinary life, Vermeer's art offered respite. He appealed to the sophisticated and sensitive viewer. Vermeer's paintings provided a challenge. How should one interpret Vermeer's paintings such as *Woman Holding a Balance* (page 79) or *The Music Lesson* (page 67)? In the hands of lesser artists, narrative readings of such scenes would be obvious, but Vermeer's ambivalent treatment lays open many viable interpretations. The clues are so subtle that they may not be clues at all, simply incidental detail included to make a scene more persuasive. A Vermeer painting is the equivalent of a detective story, offering the acute intelligence of a diversion that cannot be definitively resolved. Therefore, the intellectual content of Vermeer appeals to the imagination and inductive reasoning of the audience, quite aside from the poetic atmosphere and virtuosic technique.

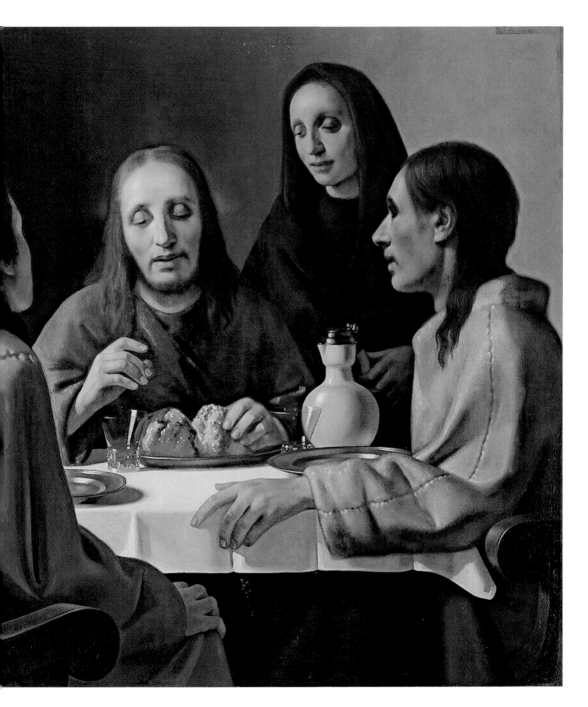

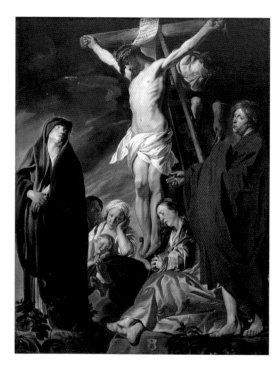

Jacques Jordaens, *The Crucifixion of Christ*, 1617–20

In the late 1930s, understanding of Vermeer's art was altered by a series of spectacular finds. In 1937, Golden Age expert Abraham Bredius was asked to assess a newly discovered large painting by Vermeer showing the resurrected Christ dining with his disciples. Bredius studied the canvas first hand and proclaimed in *The Burlington Magazine* that he was satisfied that this was a masterpiece from Vermeer's early period. It was quickly purchased by the Boijmans van Beuningen Museum, Rotterdam, a major Dutch museum without any Vermeers. In 1869, a public subscription had failed to raise sufficient funds to acquire *The Lacemaker* (page 89) for the city; the museum considered it unthinkable to allow this new opportunity to pass. Further paintings from this early period appeared—all Biblical paintings, similar to *The men at Emmaus* (page 35)—and these were accepted and acquired by museums and collectors for very high prices.

It was only in 1945, when the seller, artist Han Van Meegeren (1889–1947), was charged with collaboration for selling a rediscovered early Vermeer to Hermann Goering, that the truth was revealed. These early Vermeers were fakes and had been made by Van Meegeren himself. This small body of paintings possessed a heaviness in physiognomy and clumsiness in execution. Van Meegeren had cleverly anticipated what art historians and museum directors wanted to discover—masterpieces by the most valued and least prolific of all major Dutch painters—and had made fabricated pictures that incorporated elements from authentic paintings, blending these with what experts had theorised should have existed. For example, the quasi-pointillist treatment of bread of *The men at Emmaus* echoed that found in *The Milkmaid* (page

57). In his trial for collaboration, Van Meegeren demonstrated to the court his techniques and materials, proving beyond doubt that he had deceived experts.

The initial success of Van Meegeren's fakes reveals that our longing to know more about the artist and to see a "new" Vermeer is powerful enough to overcome our credulity and visual evidence. Our love for Vermeer's art of unparalleled sensitivity leaves us open to beguiling lies. For its superlative achievements in diligence, technique, brevity and poetry, Vermeer's art is justly regarded as the apex of Dutch—and even perhaps Western—painting.

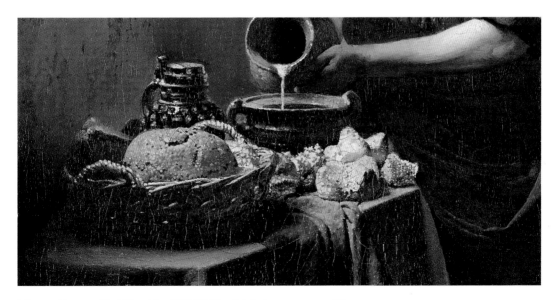

Johannes Vermeer, *The Milkmaid*, c. 1658/59 (detail, full picture see page 57)

WORKS

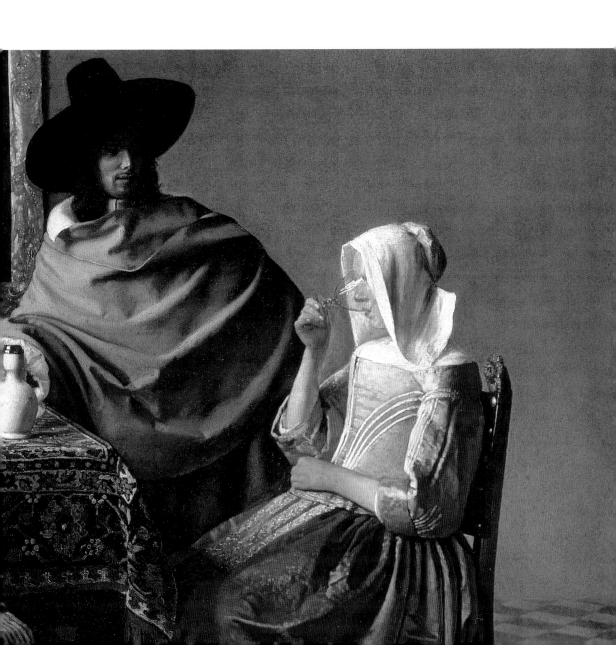

Christ in the House of Mary and Martha, c. 1654/55

Oil on canvas
158.5 × 141.5 cm
National Galleries of Scotland, Edinburgh

This is the artist's largest painting and was likely commissioned by a private patron. It depicts Mary and Martha of Bethany welcoming Christ into their home by offering food. Bread here is not just a symbol of the women's hospitality but a foreshadowing of bread as part of the eucharist. The background architecture is not designed to be an accurate depiction of a building but rather a suggestion of a type of house. The heavy chiaroscuro, low viewpoint and realism all bear witness to the influence of the Utrecht Caravaggisti (followers of Caravaggio), not least Leonaert Bramer (1596–1674). Bramer was a Delft painter who is considered to have possibly been Vermeer's master, although their techniques and subjects do not overlap. The misaligned sightlines of figures is a common feature of art produced by the *camera obscura*, as the repositioning of figures or lens in order to permit correct focussing tends to produce such effects of dislocation, as seen in many genre scenes painted in the Caravaggisti style. However, the generalised treatment of the drapery in this painting shows it was not made using a *camera obscura*.
"Een graft besoeckende van der Meer 20 gulden" (a picture of the grave visitation by Van der Meer, 20 guilders) was the assessment of a painting in the possession of Johannes de Renialme, that has tentatively been identified as the Biblical scene "The Holy Women at the Sepulchre", depicting mourners at the tomb of Christ. The description was made in 1657, suggesting de Renialme bought that painting directly from the artist a year or two before the collector's death. If that inference is correct, there are only two known religious paintings by Vermeer, of which only this one survives.

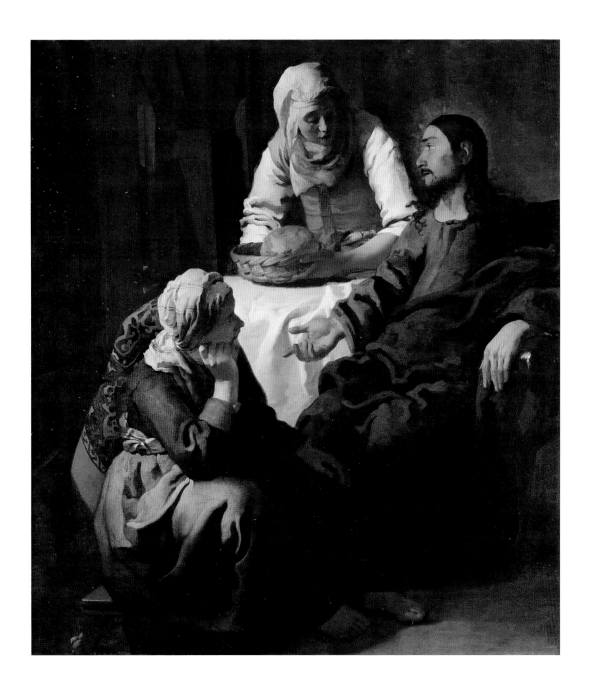

Saint Praxedis, 1655

Oil on canvas
101.6 × 82.6 cm
The National Museum of Western Art, Tokyo

Saint Praxedis was a second-century Roman saint, known for bearing witness to the martyring of early Christians and preserving their relics. To the left of Saint Praxedis is the body of a martyr, whose blood she squeezes from a sponge into a reliquary vase; to her right is a woman who may be her sister Pudentiana, herself a future martyr. This painting is a copy of a picture painted around 1640–50 by Florentine painter Felice Ficherelli (called "Il Riposo", 1605–1660). Vermeer added a crucifix to his version and slightly altered the face of the saint, but otherwise his copy is faithful to the original. But where did Vermeer see that painting? The original was in Italy at this time, so did Vermeer travel to Italy or did he see another version in the Netherlands? The notability of Vermeer spending any time in Italy would probably have been recorded somewhere, yet we have no mention of any travels. Alternatively, a copy may have reached the Netherlands by 1655; at least two versions were painted by Ficherelli. However, if that were the case, it probably did not reach Delft, as Italian paintings were very rare and expensive in the city.

The exact sequence of the three earliest surviving paintings by Vermeer is uncertain. However, measurement of lead isotopes proves that the lead white used for this painting also appears in *Diana and her Nymphs* (page 44), so we know this painting and that one were made at about the same time.

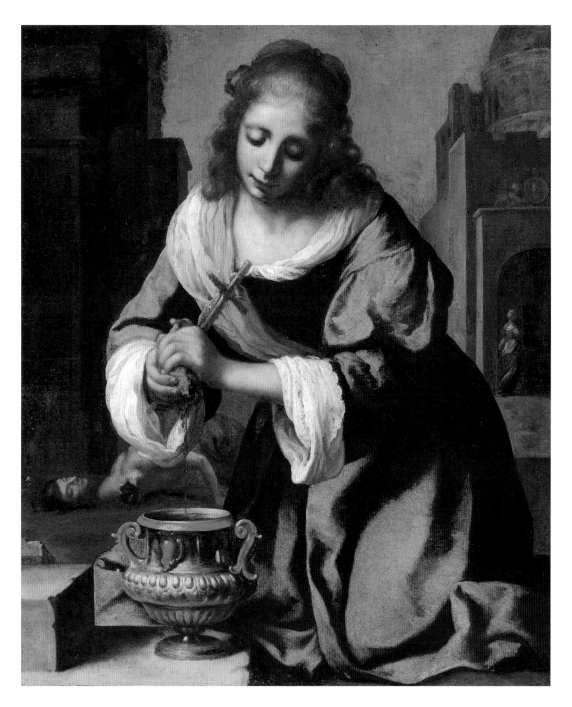

Diana and her Nymphs, c. 1655/56

Oil on canvas
97.8 × 104.6 cm
Mauritshuis, The Hague

Diana, classical goddess of hunting, was sometimes depicted with Acteon, who was punished by death for having seen her unrobed. This more reflective scene was rather in keeping with Vermeer's abilities. Common standards of decency in the Low Countries in this era established that nudity was acceptable only in certain circumstances. One of these was mythological painting. The fact that Vermeer refrained from depicting the goddess nude may have been due to the request of a patron.

Some historians consider this sombre scene was intended as an indirect response to the tragic deaths of the *Delftsche Donderslag*. It incorporates melancholic overtones found in depictions of the washing of Christ's feet. The thistle was a symbol of self-denial and suffering in Christian art. It was not uncommon for artists to include such Christian symbols in mythological works, drawing parallels between the two sets of beliefs and implying that Greek legends prefigure the life and teachings of Christ. Vermeer commenced his career with the intention of focussing on mythological paintings and religious scenes, the two highest genres of art. A painting of Jupiter, Venus and Mercury was attributed to Vermeer and sold at auction in 1761. It is now untraced.

Historically, paintings were frequently trimmed—and sometimes expanded—to match spaces in rooms or fit pre-existing frames. About 15 centimetres of the right side of this canvas have been trimmed at some time. Older photographic reproductions show the painting when it had foliage and sky painted in the top right corner, which recent restoration has removed.

45

The Procuress, 1656

Oil on canvas
143 × 130 cm
Gemäldegalerie Alte Meister, Dresden

In a brothel, a young soldier propositions a prostitute with a coin, as a procuress watches with avidity. They are accompanied by a drinker in a fancy costume who looks at us. The man on the left has been considered a self-portrait, something corroborated by the fact that the same jacket is worn by the artist in *The Art of Painting* (page 93), which itself is seen as an idealised indirect self-portrait. In genre scenes, a figure who is slightly detached and faces towards the viewer is often a self-depiction of the artist, who invites the audience to regard the events portrayed with amusement and moral superiority. The smirk of the young man and the phallic lute neck in his hand indicate the lewd nature of the transaction.

Pictorially, the inclusion of the rug and jug anticipate *A Maid Asleep* (page 49) and following works. The dramatic division of the picture space into a figured upper part and unfigured lower part, can be found in balcony scenes. The layout will become Vermeer's preferred one.

When considered within Vermeer's corpus, this painting seems incongruous. Here we have a depiction of intrigue, prostitution and cheery bonhomie, including a coarse casual groping. It is full of strong flavours (especially lewdness), all of which seem distinctly un-Vermeer. Yet after the first three surviving paintings, it is this scene (decisively signed and dated 1656) that prefigures Vermeer's mature art. The three preceding paintings display an interest in the domestic and devotional life of women and this picture extends these concerns into a genre scene. Genre painting is the subject of domestic life, usually depicted in an everyday interior, that rose to prominence in seventeenth-century Dutch art as a way of allowing artists to convey morals without encroaching on the field of religious painting, which was considered politically sensitive. The development of the landscape, flower painting and still-life in this period likewise avoided sectarian divisions of Dutch life.

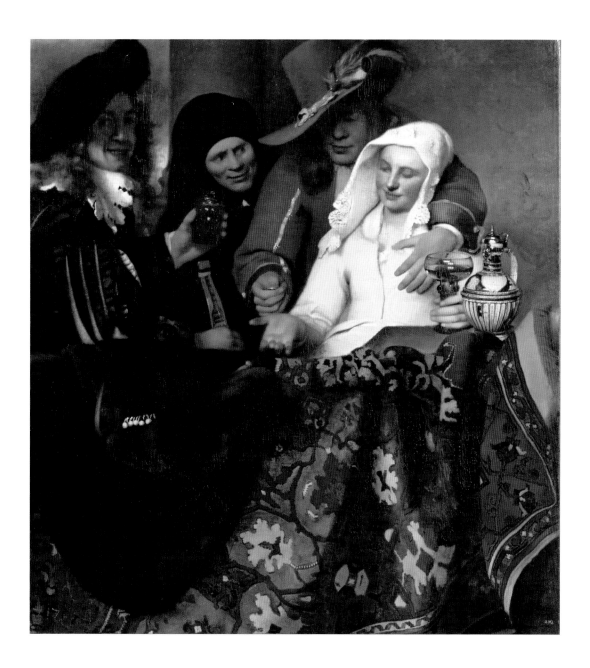

A Maid Asleep, c. 1656/57

Oil on canvas
87.6 × 76.5 cm
The Metropolitan Museum of Art, New York

This enigmatic painting (along with *Girl Reading a Letter at an Open Window*, page 51) is seen as a transitional work, marking the advent of Vermeer's mature style. Here is the start of the artist's true subject—the interior life of Woman, usually alone—which was hinted at in earlier paintings and now comes to the fore, distilled to its essence. As evening falls, a drowsy maid sits at a table with a rug, fabric and fruit. Our vantage position is from above. We stand over her, as a member of the household would have done when coming across this scene. Flushed cheeks, loosened bodice and sleepy expression indicate the maid has been drinking, something confirmed by the jug and glasses. She has drunk with an absent companion, we surmise. The overturned glass suggests carelessness or the hasty departure of the fellow drinker. There was a dog in the doorway, facing towards a man in the back room; both were painted out in order to allow us freedom to speculate about the maid's dreams and appreciate the atmosphere. Vermeer invites us to meditate upon the poetic rather than laugh at the satirical or judge the didactic.

The maid's apparel has attracted comment. Some have seen her as so well dressed that perhaps she is the mistress of the household rather than its servant. Confusion caused by people dressing inappropriately for their rank or occupation was considered disruptive and misleading, as it led to misidentification of social status, thus facilitating deception. This maid may be dressed rather finely but Vermeer does not portray her in an unsympathetic light. We might compare this ambiguity to Fabritius's painting of a sentry (page 21) executed only a few years earlier. Samuel van Hoogstraten's *The Slippers* (page 31), made at about the same time as Vermeer's painting, gives a point of comparison, with a view looking through interior doorways. This painting was bought by the Ruijvens and marked perhaps their first purchase, which commenced a stream of valuable patronage throughout Vermeer's lifetime.

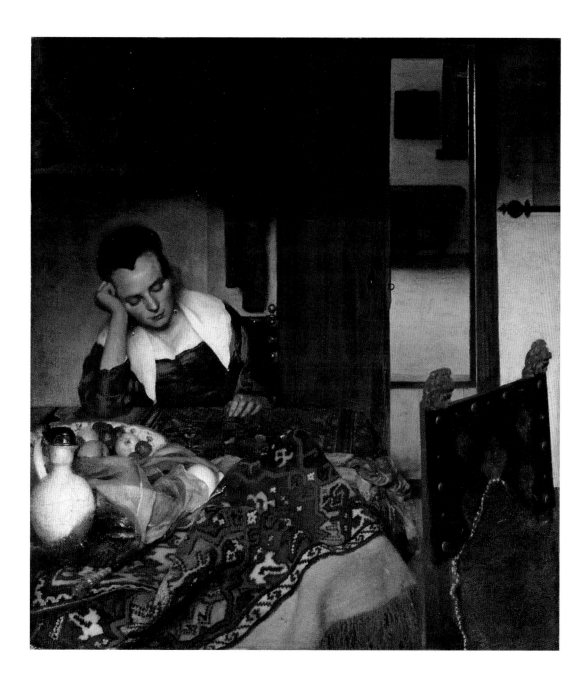

Girl Reading a Letter at an Open Window, c. 1657/58

Oil on canvas
83 × 64.5 cm
Gemäldegalerie Alte Meister, Dresden

Girl Reading a Letter at an Open Window is one of Vermeer's most serene and restrained works. The impassivity of the woman tells us nothing about the contents of the letter or anything about her circumstances. Indeed, the appearance and imagery do not invite a narrative interpretation. This is clearly a demonstration of skill, one certainly not cynical nor without feeling, but very much a test of a young artist's technical ability and viewer's emotional engagement with an unforgettable scene that lacks story and moral.

The curtain on a rail was included in *trompe l'œil* paintings which sought to triumph over (or fool) the eye by using illusionistic imagery and extreme detail. This was done by including something that seemed to be a real element extraneous to the painting (such as a curtain or false frame) or by depicting an object foreshortened so as to jut into the real space of the observer. A perfectly rendered fly casting a shadow on the painting surface would fool a viewer into waving it away. Some paintings, especially church interiors painted by Emanuel de Witte in the early 1650s, include painted rods and curtains that cast shadows upon the picture surface.

An extensive restoration of this painting was carried out from 2017 to 2021, which consisted of removing old varnish and overpainting. It resulted in a slight reduction of the painting on all sides, restoring the painting to its original (surviving) surface. The most dramatic change was the revealing of a picture of a cupid on the back wall, previously painted out by a later hand. This dramatically alters the appearance and mood of the painting. The allegorical figure of cupid reminds the woman that she is ruled by true love, which overcomes trickery. This particular depiction has been traced back to an engraving from a book called *Amorum Emblemata* (1608). While restoration has given us the painting as Vermeer intended it, earlier viewers will miss the visual restraint provided formerly by the unadorned whitewashed wall (page 32).

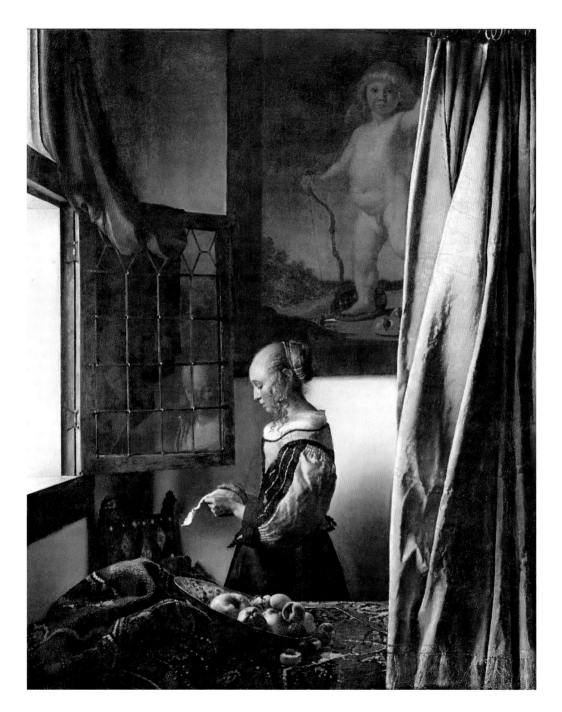

Officer and Laughing Girl, c. 1657/58

Oil on canvas
50.5 × 46 cm
The Frick Collection, New York

Another work that once carried a fake signature of de Hooch, this early Vermeer painting presents the first of many maps in his output. The map is of the Netherlands, orientated with the North to the right, rather than at the top side. Is the dominant blue hue of the map an effect that was intended or something that has come about due to fading of yellow pigment, turning a green mixture blue? Dutch maps of this era sometimes emphasised waterways, as these were economically, politically and militarily important. Maria Thins's family were involved with overseeing the important task of preservation and maintenance of canals and dykes, a responsibility that required detailed up-to-date maps.

During the years 1655–57—when Vermeer was painting *A Maid Asleep* (page 49) still within the bounds of a moralising genre picture, such as those painted by Adriaen van Ostade and Adriaen Brouwer—fellow Delft painter de Hooch had progressed to more realistic scenes, depicting space more accurately with a tightened style. At this time, Ter Borch's subjects included the lone female figure or his paintings were conversation pieces with a few figures in domestic interiors. It seems that Vermeer quickly picked up on the potential of these advances by his colleagues.

The dark bulk of the man seems too large in comparison to the woman. Did the looming presence of the man in the foreground seem to Vermeer to be an intrusion or a distraction? Whichever was the case, such foreground figures do not appear in later multi-figure paintings.

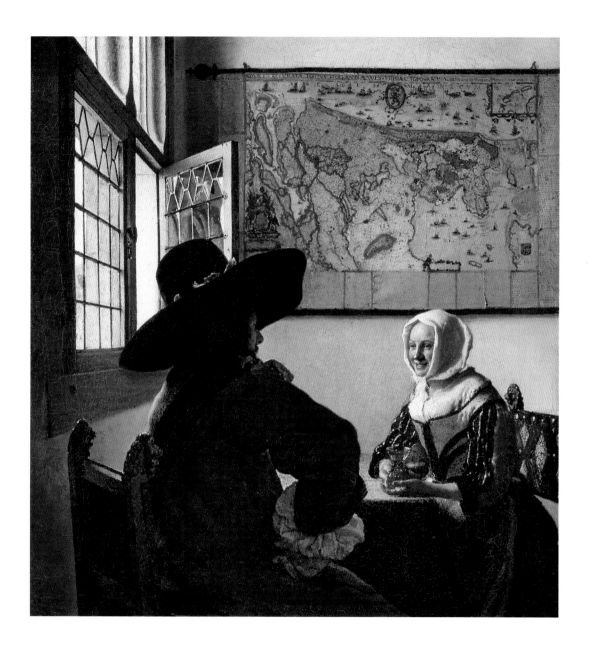

View of Houses in Delft (The Little Street), c. 1658/59

Oil on canvas
54.3 × 44 cm
Rijksmuseum, Amsterdam

This painting has become emblematic of Dutch town life during the Golden Age. We do not think of Vermeer as a painter of town views, but—not forgetting the great achievement of *View of Delft* (page 65)—there was at least one other street view of this type by him. It was recorded in an auction list of 1696 but has since been lost. This one seems to be a response by Vermeer to Pieter de Hooch's scenes set in streets and courtyards (page 15), which de Hooch had created a year or two before the suggested date of this painting. In the late 1650s, de Hooch moved from a loose style to a tighter technique that defined figures, spaces and lighting in a much more realistic manner; it was this style that drew admiration from collectors and fellow painters alike.

The view through the doorway into the external passage breaks the otherwise overwhelmingly flat line of house fronts. The receding diagonal of the dark line in the street joining the wall of the passage pierces the façade and reaches the inner courtyard beyond. The framework of verticals and horizontals and slabs of colour placed perpendicular to the picture surface anticipate the abstraction of Piet Mondrian by over 250 years. Although there is considerable distance between the tastes and conventions of the ages, the two artists are unified in their meticulous attention to the fundamentals of composition.

Much effort has been expended attempting to discover the location of this view. Binstock has proposed that the building on the right is the house of Vermeer's mother-in-law, Maria Thins, which she shared with the painter's family.

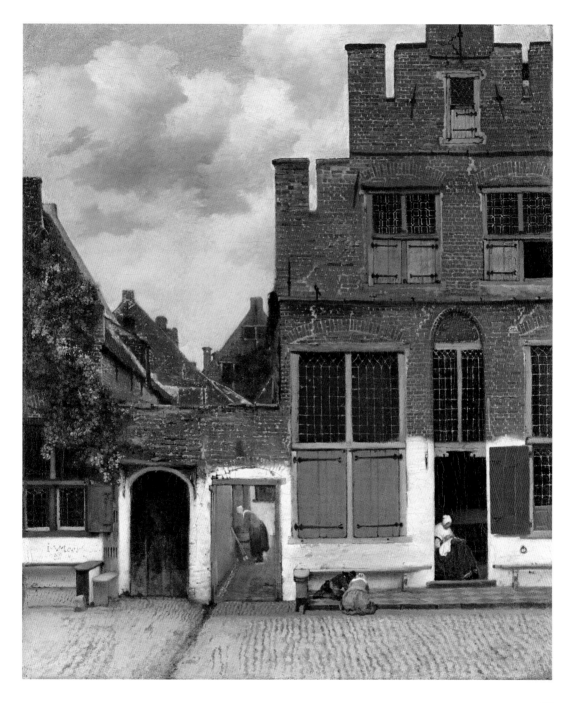

The Milkmaid, c. 1658/59

Oil on canvas
45.5 × 41 cm
Rijksmuseum, Amsterdam

There is an almost miraculous quality to the way this milk curls as it runs and how the grains on the loaves are speckled by light. This milkmaid is making bread pudding; it is an activity seen as typical of the frugality, practicality and competence ascribed to the Dutch. A broken windowpane indicates the modest circumstances of the household. The skirt was painted in monochrome and tinted with layers of ultramarine. The falling trickle of milk is directly below the disappearing point, which is located above the wrist of the milkmaid's right hand.

The painter's artifice is apparent in the odd shape of the table, clearly either especially selected or made for this composition. The monumental character of the woman is accentuated by the emphatic modelling of volume, low viewpoint and strong outline. To achieve the latter, the painter removed jugs on the rear wall and a basket of laundry on the floor, replacing it with a footwarmer, heated by a lit coal. The small size of that common domestic object reinforces the dominance of the milkmaid in the picture. The tiles at the bottom of the wall were produced in Delft and exported across Europe, a point of pride for the city's residents.

This painting belonged to the famed Six Collection in Amsterdam, established by Jan Six in the seventeenth century. When *The Milkmaid* was offered for sale by the trustees of the collection, there was much debate in the Netherlands about saving this painting for the nation. This was eventually done when *The Milkmaid* was acquired for the Rijksmuseum in 1908. The public attention and state acquisition—as well as the sentimental appeal of its humble content—has made *The Milkmaid* a Dutch national icon.

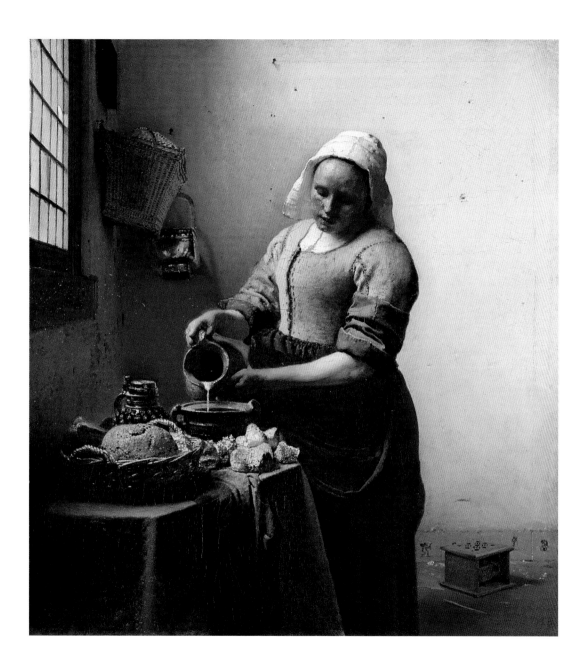

The Glass of Wine, c. 1659–61

Oil on canvas
67.7 × 79.6 cm
Gemäldegalerie, Staatliche Museen zu Berlin

A young cavalier stands next to a young woman as she drains a glass of wine; his hand rests upon a jug, as he waits to refill her glass. A lute is on the chair and musical scores upon the table. It may seem peculiar to us, but gentlemen and soldiers still wore their hats indoors, as seen in many paintings. The soldier and drinking woman is a subject common to works of this period. Although Vermeer would later be celebrated for more original subjects and less jovial scenes, at this point in his career his art is almost indistinguishable from that of his peers. At one time, the painting bore a forged signature of de Hooch—a plausible linkage, done in order to increase the value of the work, which lacks Vermeer's signature. Ter Borch's *A Gentleman Pressing a Lady to Drink* (page 27) from 1658/59 may have been a prompt for—or a response to—Vermeer's picture.

The red dress stands out as a dazzling piece of description. The folds and highlights are beautifully captured. The dress, the gentleman's upper garment and the crisply defined stained glass all mark a noticeable move towards realism, following the leads of Ter Borch and de Hooch, and departing from the school of Rembrandt's reliance upon placing figures against shadows. Nonetheless, this picture is still the work of a young painter. The uneven recession of floor tiles is indicative of a painter still learning his craft, adding to the charm of this painting.

Over the 1660s, Vermeer became increasingly cautious about using red. Patches such as the striking red jacket of *Officer and Laughing Girl* (page 53) and the red dresses found in early paintings largely disappear by the early 1660s and only make a single notable reappearance in *Girl with a Red Hat* (page 87). Cool tonality matches the emotional distance and narrative reticence that come to characterise Vermeer's painting. The fierce effect of large areas of hot hues (with implications of action and danger) were incompatible with Vermeer's contemplative art.

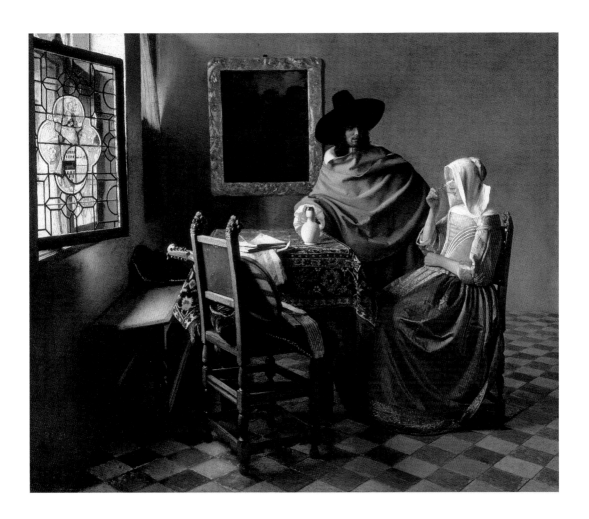

Girl with a Wine Glass, c. 1659–61

Oil on canvas
77.5 × 66.7 cm
Herzog Anton Ulrich-Museum, Braunschweig

A man is slumped in melancholic apathy, numbed by alcohol, as his companion takes advantage of this opportunity to woo the lady. As is common in genre paintings of domestic settings, it is the man who urges the woman to drink, so that he may lower her resolve and potential resistance to his charming persuasion. This dynamic is reversed in brothel scenes, where the mercenary madam or prostitute takes advantage of the man's animal drive. The flaw of the painting is the awkward smile of the girl, which has the unfortunate overtones—unintended, it seems—of a leer. The exposure of teeth at the time was considered unseemly and indicative of diminished restraint, base urges and of belonging to a low class. In this case, Vermeer was invoking to the first quality.

The portrait painting in the background is potentially a variation after a Frans Hals portrait. Wheelock suggests that the choice of the portrait is a sombre reminder of a gulf between the standards of morality and comportment of the date of the portrait (the 1630s) and when Vermeer painted his scene. This is reinforced by the design of the window, which depicts the personification of temperance, with the obvious injunction that all benefit from the exercise of restraint, particularly regarding the consumption of alcohol.

The madder lake (extracted from the roots of the *Rubia tinctorum* plant) and vermilion (from the mercury-sulphide mineral cinnabar) that were the pigments used to paint the dress, play decreasingly less important parts in Vermeer's palette in the coming years. Vermeer used a combination of opaque imprimatura vermilion paint and then, over that, a glaze of madder lake. Glazes are suspensions of small amounts of pigment in a clear binding agent producing a transparent tint that is applied over a pigment-dense layer beneath. Glazing produces an effect that is stronger and more nuanced than simply mixing pigments and applying them as an opaque paste.

The fact that both this and the preceding painting feature the same window and floor that never appear in his paintings again suggests that these paintings may have been commissioned by a patron, who requested the setting to be his or her home. This painting is sometimes titled *The Girl with Two Men* to differentiate it from *The Glass of Wine* in Berlin.

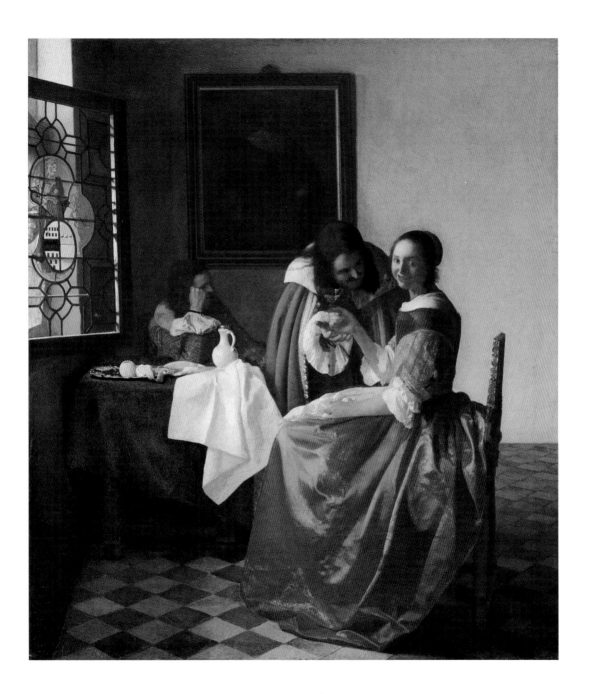

Girl Interrupted at her Music, c. 1659–61

Oil on canvas
39.4 × 44.5 cm
The Frick Collection, New York

Music-making was considered a social accomplishment, as well as a mark of cultural education, in addition to its function as mere entertainment. It revealed humanity's unique appreciation of aesthetic form and moral instruction, but (if indulged in indiscriminately) it could encourage sensual abandon and immorality. The ravages of time have made the moral of this painting impossible to decode. Removal of overpainting in 1907 uncovered a picture of a cupid, who holds a card, but that card has been effaced. Therefore, interpreting the moral (which is dependent upon that symbol) is impossible. Early interpretations drew parallels between the woman's situation and that of a caged songbird. However, scientific tests tell us that the cage was added in the nineteenth century.

We can see that Vermeer was not only a pioneer but also a follower of contemporary taste. At the time when this painting was made, Vermeer abandoned the landscape format for the portrait format in his genre scenes. The earliest (and crudest) genre paintings are horizontal in layout, which assists with narrative reading, the way one reads a sentence as a sequence of words in a specific order. As fashion changed, de Hooch, Ter Borch and Mieris brought in more sophisticated painting, made in the fine manner and more narratively opaque; thereafter, the older approach became seen as quaint and anachronistic. If the sequencing of the paintings is correct, *Girl Interrupted at her Music* is the last surviving Vermeer painting in the old horizontal style.

The history of this canvas is representative of the fate of many Vermeer paintings. Its first recorded owners were a family living in Amsterdam; by inheritance it entered the collection of Dutch aristocracy before 1810, when it passed into the Dutch picture trade. It made its way to England by 1853, first to London, then Essex and later to Clifton, Bristol. By 1900, long recognised as a valuable Vermeer, its owner sold it for £2,500 to a London dealer. It then crossed the Atlantic Ocean, in the ownership of dealers Knoedler & Co., New York, who sold it to millionaire Henry Clay Frick. It remains in Frick's house museum, off Fifth Avenue, one block from Central Park on Manhattan.

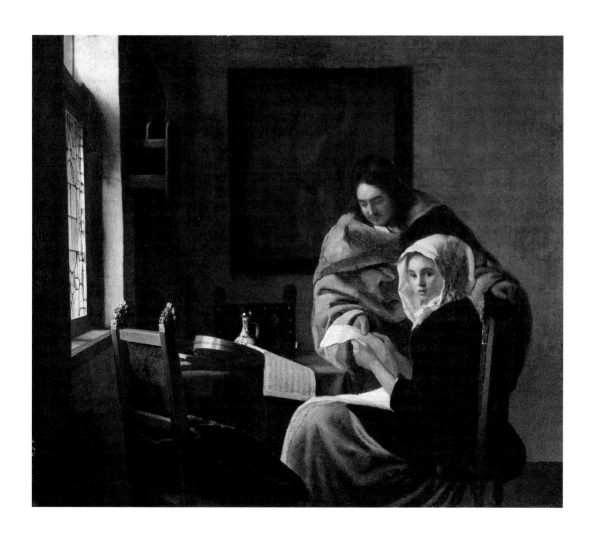

View of Delft, c. 1660/61

Oil on canvas
96.5 × 115.7 cm
Mauritshuis, The Hague

This astonishing painting portrays Vermeer's home city as a flattened band, the size and tonality of the dark cloud hanging heavy above it, and with a glimmering glimpse of sunlit buildings in the distance. Just as Vermeer used in his interiors the *repoussoir*—a pictorial device meaning "push back" in French, where the main motif is separated from the viewer by the intrusion of a dark form in the foreground, introducing greater pictorial depth—here he puts parts of the city behind a dim ribbon of buildings. Views by other artists reveal that Vermeer flattened and narrowed the buildings for his own purposes. The prominence of the sky and the near emptying of the foreshore provides an emphatic framing of the strip of buildings, causing the observer to concentrate on the architecture. The church tower of Nieuwe Kerk (where the artist was baptised) is seen on the right; it was shortened to balance the tower and cupola left of centre. The fortification with twin towers, the Antwerp Gate, had its frontage flattened and made parallel to the picture plane.

The likelihood that this daring painting was a private commission (as there is no indication it was a civic one) would explain how Vermeer was free to make considerable alterations to topographical reality. Impasto was applied in tiny blobs to the tower of Nieuwe Kerk, which catches the light and makes the building glitter, drawing the gaze as it would in real life. Sand was used to give texture to the roofs. Vermeer turned the bustling quay into a strangely quiet setting. As in *The Little Street* (page 55), Vermeer has made a normally busy view into a tranquil one. He peopled it with the bare minimum of staffage (figures added to a painting to impart incident and indicate scale). Vermeer found he could do with even fewer figures; we surmise this because he painted out one man. This figure is gradually reappearing due to the oil paint becoming transparent over time; this chemical process, called "saponification", is an inevitable aspect of oil-based paint.

In the novel *À la recherche du temps perdu* (written 1909–1922), Marcel Proust (1871-1922) wrote for his art-critic character Bergotte the following reverie: "At last he came to the Vermeer which he remembered as more striking, more different from anything else he knew, but in which, thanks to the critic's article, he noticed for the first time some small figures in blue, that the sand was pink, and, finally, the precious substance of the tiny patch of yellow wall. His dizziness increased; he fixed his gaze, like a child upon a yellow butterfly that it wants to catch, on the precious little patch of wall." Writers have debated which patch of wall Proust meant. Most likely seems the wall on the far right, to the right of the Rotterdam Gate and above the drawbridge.

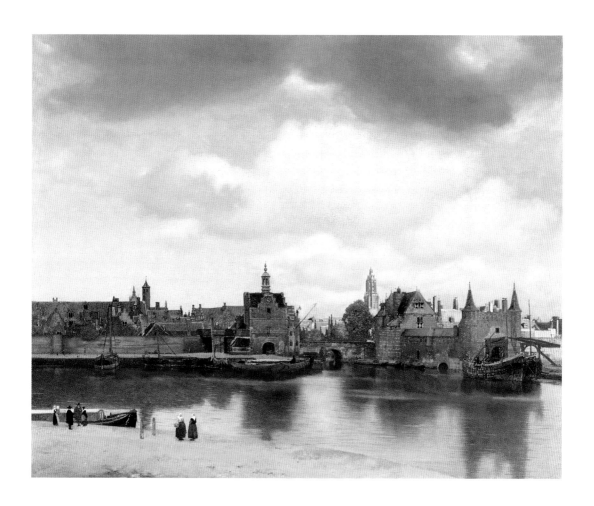

The Music Lesson or
Lady at the Virginal with a Gentleman,
c. 1662–64

Oil on canvas
73.3 × 64.5 cm
Royal Collection Trust, London

Rather than a music lesson, it seems a young woman is playing for a male visitor, without a chaperone, which is a noticeable feature of Vermeer's paintings. The painting on the far right has been identified as van Baburen's *Cimon and Pero (Caritas Romana)*. The Latin inscription on the virginal (a keyboard instrument predating the piano) is "MVSICA LAETITIAE COMES MEDICINA DOLORVM", which has been translated as "Music is the accompanist of joy, a remedy for sorrow". A viola da gamba lies on the floor. The purple tint of the window glass was produced using a mixture of ultramarine and red lake.

Vermeer made adjustments to the composition as he worked. The reflection in the mirror shows the lady looking more to the right than she should, were the reflection true. No painter at this time (including Vermeer) was rigidly realist. Artifice and internal inconsistencies were not only accepted but playfully employed to amuse, puzzle and intrigue. In the mirror is a reflection of the artist's easel, an indirect reminder of the artificiality of the scene. Vermeer makes us aware of his presence and perhaps draws an analogy between the woman articulating sound to himself articulating light and colour on the painting surface.

It is curious that a large proportion of paintings in Vermeer's oeuvre have pairs, consisting of paintings almost the same size and of related subject matter. Whether this is the result of Vermeer wanting to rework a subject or a collector asking for a similar painting—or even a collector requesting a pendant (accompanying) picture—we cannot tell. In the case of *The Music Lesson* and *The Concert*, we have our first example.

The 2013 documentary film *Tim's Vermeer* followed the quest of inventor Tim Jenison to paint a replica of *The Music Lesson* using a *camera lucida*, which used a lens and a small mirror. Using this device—one not beyond the skill of seventeenth-century Dutch craftsmen—the non-artist made a creditable transcription of a *mise en scene* with models, musical instruments and pictorial space, all faithfully arranged as in Vermeer's design. This experiment demonstrates that optical devices could assist in the production of paintings similar to Vermeer's. Whether Vermeer employed such devices when he painted remains unknown.

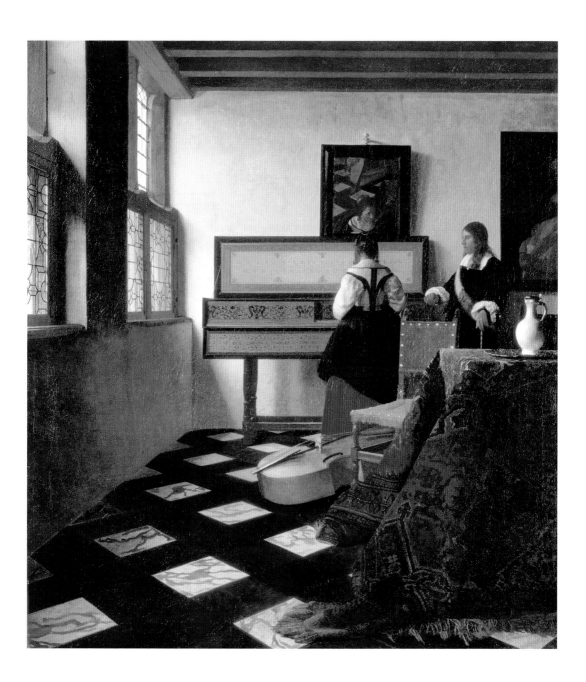

The Concert, c. 1662–64

Oil on canvas
72.5 × 64.7 cm
Isabella Stewart Gardner Museum, Boston (stolen)

A trio of music-makers perform for themselves without an audience. A woman plays the harpsichord and a man plays a lute as a standing woman sings. There is a comparison with a less savoury musical gathering in the painting on the wall, which shows a prostitute, brothel madam (a procuress) and a male client. Vermeer assembles a group that counters that mercenary and lascivious scene, thereby providing us with a glimpse of his sense of humour. Another painting hangs on the wall—a landscape in the style Jacob van Ruisdael (1629–1682).

The bottom edge of the landscape frame, the horizon of the scene on the harpsichord and the bottom edge of the frame of van Baburen's *The Procuress* (page 18) all align with the man's (hidden) eyes. The gentle slope (top left downwards) of the paintings and the mild curve of the harpsichord's lid are counterbalanced by the slight diagonal line running the other way through the three heads. Strong verticals of the figures and chairs are matched by the orthogonals of the picture horizons, frames and tabletop. Lower, the tiles add some energy and their recession draws us into the picture space. Marble tiles were rare and only found in the most public of rooms in the homes of the wealthiest. Given the fact that Vermeer seemed willing and able to alter the appearances of the rooms in his paintings, it is possible that the marble-tile checkered floors did not exist in his house and were invented, following observation of floors elsewhere.

This painting may have been made as a pendant to the preceding painting. It was once owned by Thoré-Bürger before it was acquired by Isabella Stewart Gardner in 1892. After her death, her collection became a public museum. On 18 March 1990, this painting, and others (including Rembrandt's *The Storm on the Sea of Galilee* (1633)) were stolen from the Isabella Stewart Gardner Museum, Boston. At the time of publication of this book, it is still unlocated and is considered the most valuable stolen painting in the world.

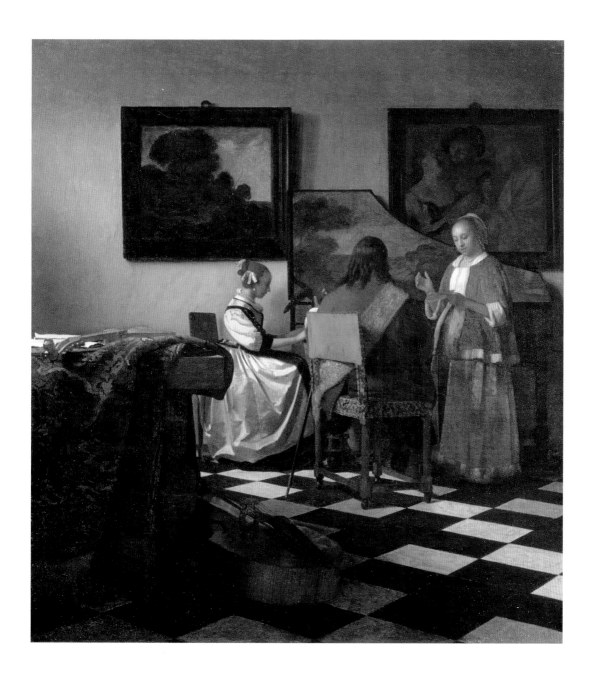

Young Woman with a Water Pitcher, c. 1662–64

Oil on canvas
45.7 × 40.6 cm
The Metropolitan Museum of Art, New York

This painting is the first of a series of pictures of solitary women engaged in ordinary situations, that are the so-called "pearl pictures". Putting these paintings into chronological order—which all are thought to date from 1662 to 1664—is a matter of speculative reasoning, although examination of the threads shows that this painting and *Girl Interrupted at her Music* (page 63) came from the same bolt of cloth. That positions this painting at the beginning of the paintings of solitary women.
The young woman engages in domestic work by an open window. Although Vermeer often painted open windows, we get no views, only a sliver of undescriptive architecture seen through the window glass of *Officer and Laughing Girl* (page 53). The luminosity of the light-infused veil illuminates her left cheek. Always adjusting his designs for clarity and harmony, the artist removed a chair and moved the map on the wall during the process. The red of the carpet complements the blues of the dress and chair fabric. Inclusion of a white veil and collar allow Vermeer to revel in tinted shadows and reflected colour, something we find to a lesser degree on the brass pitcher. Vermeer was not the first Dutch painter to appreciate that objects take on the colours emanating from adjacent surfaces, but he was uncommonly attuned to the phenomenon.
There is mention of a lost Vermeer painting of a woman pouring wine, of which no reproduction print has been found. This is, sadly, the case for all of the lost Vermeers. Reproductive prints—engravings, etchings and mezzotints—were made to record significant works of art and thereby allow connoisseurs and students the chance to study them. Vermeer's art was not considered important enough for this until after his rediscovery, with the rare exception being an eighteenth-century engraving of *The Astronomer* (page 95).

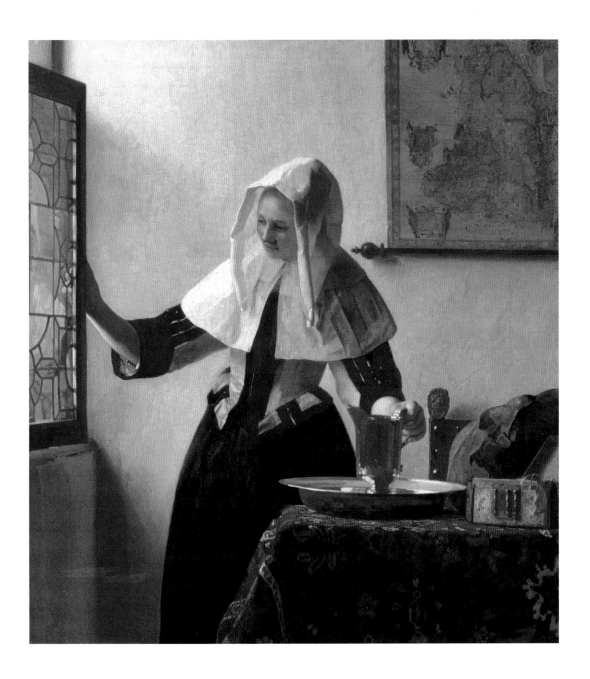

Woman in Blue Reading a Letter, c. 1662–64

Oil on canvas
46.5 × 39 cm
Rijksmuseum, Amsterdam

The painter returns to the subject of a previous picture: a woman reading a letter by a window. This woman forms a triangle (or cone), with her blue-clad torso in the centre of the picture, balanced between two parts of light wall and two areas of darkness (map and table with chair). In a visual equation, she acts as a fulcrum around which other elements are organised. Reappearing is the map seen in *Officer and Laughing Girl* (page 53), with the blue coloration drastically reduced.

On 29 July 1888, Vincent van Gogh wrote to his painter colleague Émile Bernard: "[D]o you know a painter called Vermeer, who, for example, painted a very beautiful Dutch lady, pregnant? This strange painter's palette is *blue, lemon yellow, pearl grey, black, white*. Of course, in his few paintings there are, if it comes to it, all the riches of a complete palette, but the arrangement of lemon yellow, pale blue, pearl grey is as characteristic of him as the black, white, grey, pink is of Velázquez." Van Gogh had been exhilarated by visits to the Rijksmuseum, which had reopened in a new building in 1885. Vermeer had caught van Gogh's eye because of his constant and limited palette.

Identification of the subject as pregnant has been highly debated. Pregnant women were very rarely depicted due to aesthetic and social reasons. It is unlikely any woman other than the artist's wife would consent to be depicted in art in such a condition. Most writers consider the cut of the clothing deceptive and that the woman is not pregnant. Vermeer carefully altered the composition to balance the patches of bare wall on the left and right by extending the edge of the map leftwards after it had been initially finished. He also rounded the figure's contour by making the jacket less angular and bulky.

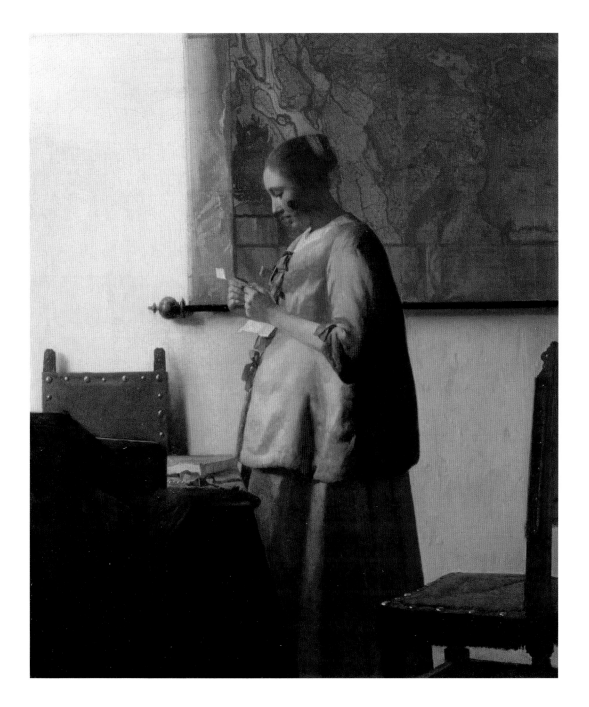

Young Woman with a Lute, c. 1662–64

Oil on canvas
51.4 × 45.7 cm
The Metropolitan Museum of Art, New York

A lone woman tunes a lute whilst looking out of a window. Is she watching for the arrival of a guest for whom she wishes to play? This enchanting painting has been badly abraded, which has removed the top layer of paint in some places. However, even in its pristine state, this must have been one of Vermeer's most chromatically and tonally subdued paintings.

In common with the other solitary-women paintings of the early 1660s, space is implied rather than defined through the placement of objects and figures in measurable means within a room. The only bright colour is the yellow of the fur-edged silken house jacket. The chair finial and blue sheet roughly echo the lines of the head and outstretched arm of the woman. These diagonals (and those of the receding edge of the table) cause the gaze to wander back to the glimmering figure, who provides the sole animation and sharp contrasts in the painting. Even the little of the checkered tiles that are visible are muted, providing no sharp tonal accents. Many of the highest horizontal lines of the window and the table edge recede towards the exact centre of the composition, located where the top of the lute body joins the neck, whereas those of the lower parts of the window and the rightmost chair converge upon the finial of the rod under the map. It is another instance of Vermeer gently distorting reality to direct our attention.

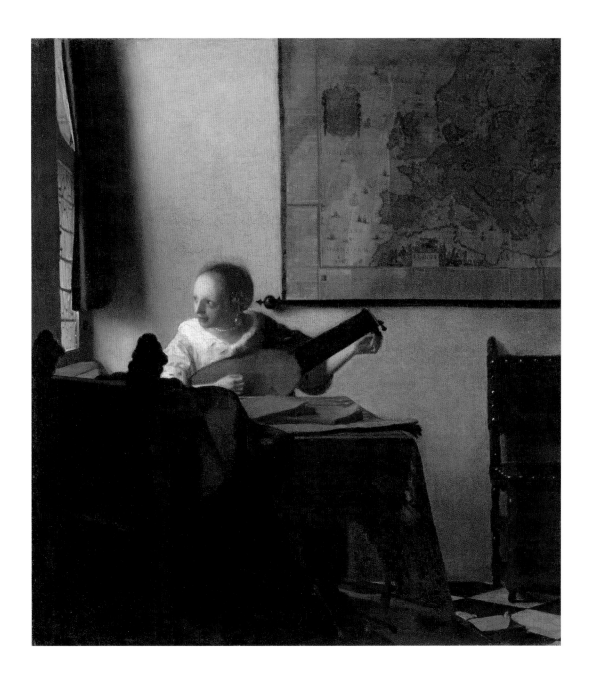

Woman with a Pearl Necklace, c. 1662–64

Oil on canvas
56.1 × 47.4 cm
Gemäldegalerie, Staatliche Museen zu Berlin

Women examining themselves in mirrors were a staple of Dutch genre painting, treated in modes that ranged from satirical to affectionate. Vermeer's tone here is appreciative, not critical. Pearls are considered a symbol of purity; the mirror—despite (on occasion) representing vanity—here stands for self-knowledge. The painting is dominated by the light pearly grey and darkened obscure forms in the lower left. These blocks cover about the same surface area each and produce a balance of yin and yang. In terms of colour, the lead-tin yellow of the jacket and curtain provide two vertical shapes on either side of the composition, forming two poles, which balance each other. The red ribbon is the only hot hue in the painting, which (as is usual for Vermeer) achieves a strong impact through very restrained means.

Neutron autoradiography reveals that the artist included a map on the wall behind but subsequently painted it over. Likewise, an instrument on the closest chair was also removed. From this we see, as we do from many instances in Vermeer's oeuvre, that the artist strove to simplify and purify paintings by removing extraneous objects that might clutter the designs and introduce distracting symbolism. His thoughts seemed inevitably to turn to the simple image, its emotional impact and capturing the poetry of daily life.

This picture, which was later owned by Thoré-Bürger, was in the artist's possession at the time of his death. Does this indicate a sentimental attachment, which caused him (or his wife) to keep the painting despite the travails of the *rampjaar*? Does that tell us something about the woman portrayed?

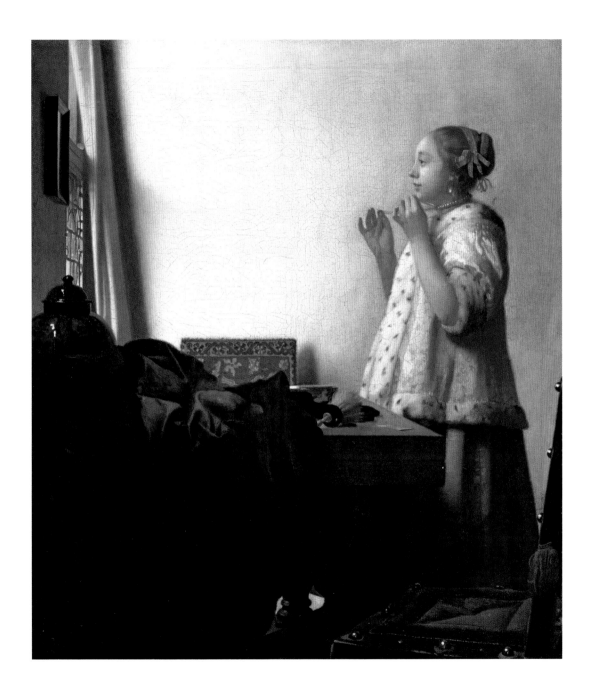

Woman Holding a Balance, c. 1662–64

Oil on canvas
39.7 × 35.5 cm
National Gallery of Art, Washington D.C.

Although first described as "a woman weighing gold" (a subject taken up by de Hooch around the time of this painting, see page 17) microscopic examination reveals the balance is empty. The painting of The Last Judgement behind the woman frames her actions and allows us to infer that the message of the painting is that a righteous life is to be lived with temperance, properly guided by consideration of religious adherence. For a time, it was considered that the subject was pregnant, making the painting a meditation upon the way the moral character of all (including those as yet unborn) are eventually subject to God's judgement. The consensus among art historians today, however, is that the subject is not pregnant.
Art historians are continually searching for a source for The Last Judgement in the background of this painting. It may have been altered or entirely invented by Vermeer, as we know he adapted pre-existing pictures and probably invented others when he incorporated them into his own paintings. We may think of Vermeer as a painter of a very limited range of topics, but in his paintings we find these pictures-within-pictures, including allegories, landscapes, portraits and religious subjects, not forgetting maps, as semi-abstract fields of schematised pattern and colour.
As this painting is the most dramatic, boldest and most complex of the pearl paintings, it is placed near the culmination of this period of his oeuvre. Hereafter, Vermeer seeks greater monumentality, less detail, and he gradually distances himself from the muted poetry and Rembrandtesque chiaroscuro of his early maturity.

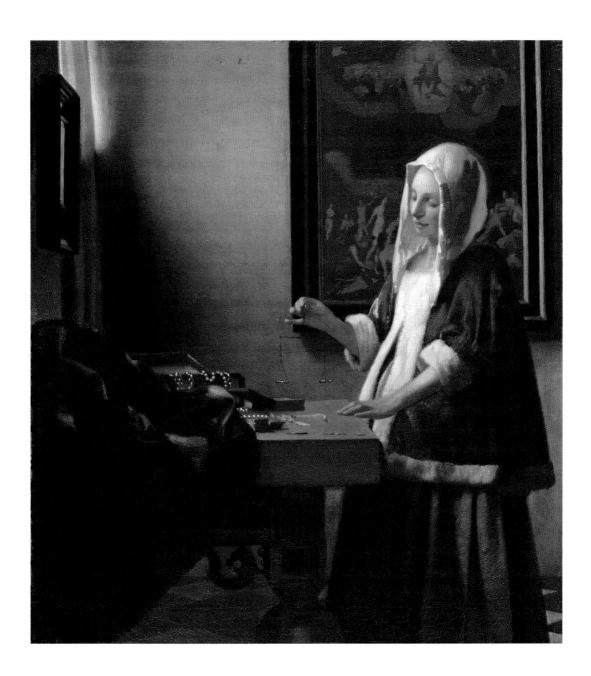

A Lady Writing, c. 1664–67

Oil on canvas
45 × 39.9 cm
National Gallery of Art, Washington D.C.

As in *Young Woman with a Lute* (page 75), this seated woman in a simply furnished room is captured in the most ordinary of daily activities, free of narrative and moral. The woman turns to look at the viewer. From the low vantage point and the woman's open expression, we might imagine this is how a mother might look towards a child, momentarily distracted from writing. Consequently, this becomes one of Vermeer's most tender paintings.

A common subject of genre painting was the woman writing a letter. Letters were an essential means of communication and pervasive feature of life in the seventeenth century, as in previous and subsequent ones. Letter writing was deemed both a necessity and a medium of eloquent expression, something that could be cultivated to the level of art.

It has been speculated that this particularly affecting portrayal is of Vermeer's wife. Despite the presence of servants, she would have had relatively little time to pose for her husband because of her domestic duties and caring for the children. However, some writers advance the case that Catharina modelled for early subjects, such as the prostitute in *The Procuress* (page 47) and *A Maid Asleep* (page 49), who has a different physiognomy. This painting exists in a space that encompasses both genre scene and individual portrait.

Whether or not this woman is the same subject as in *Woman with a Pearl Necklace* (page 77) has divided writers; the two certainly appear very much alike and their clothing is identical. The depictions of self-knowledge (contemplation) and self-expression (writing) present different facets of the complete woman.

Considering the stylistic attributes of diffuse edges, shadowy tones and fine detailing, this painting may well date from the beginning of the pearl paintings, however most authors date it later. Wheelock and Bailey date it as c. 1665, the Rijksmuseum c. 1664–67 and Schutz c. 1665–67.

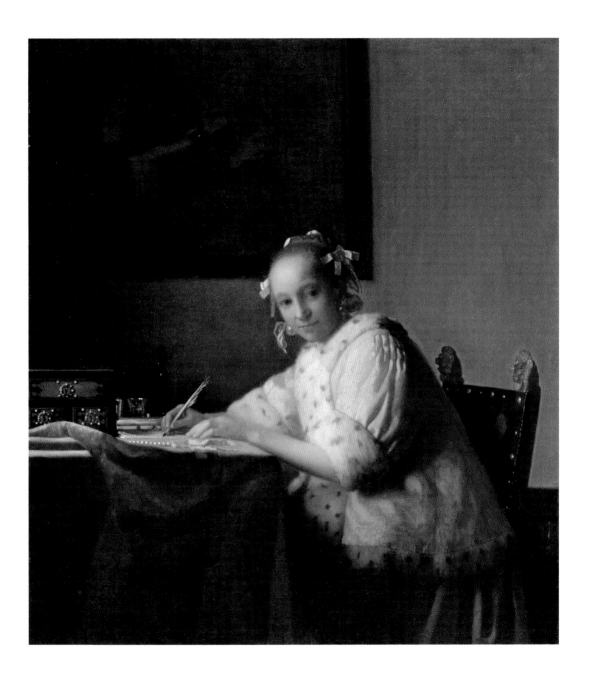

Girl with a Pearl Earring, c. 1664–67

Oil on canvas
44.5 × 39 cm
Mauritshuis, The Hague

Joining Leonardo's *Lady with an Ermine*, Titian's *Venus of Urbino*, Ingres's *Bather of Valpinçon*, Vermeer's *Girl with a Pearl Earring* has become an iconic embodiment of feminine beauty. Lively, natural, infused with an implication of spontaneity and informality—with inferred movement, opened mouth and guileless direct gaze—this painting accords to modern standards of elegance and attractiveness. It came to be called "The Dutch Mona Lisa" even before its acquisition by the Mauritshuis in 1908, as it had been in a publicly accessible collection since 1881.

Its impact is all the more striking because it is achieved through such restrained means. Blue, pale yellow and a subdued earthy green are modest foils to the face of the young woman, delicately painted with relatively little volumetric modelling. The face shines against the dark ground as a shell-like wedge held between a sweep of blue and a slash of white. There is not a straight line in the picture.

Although we view this painting as a portrait, its first viewers may have considered it a different type of painting. The *tronie* was small painting of a character head or still-life, which displayed the artist's mastery of technique and character and was retained in the studio as an example to be shown to patrons. There are three known *tronien* by Vermeer (pages 83, 85, 87) and one attributed to him (*Girl with a Flute*, page 24).

The large size of the pearl is more evidence of Vermeer's tendency to alter reality in order to maximise the impact of his paintings. Such outsize pearls are to be found in pictures by other Dutch painters, such as *Woman Writing a Letter* (c. 1655) by Ter Borch. Reality is subordinated to the imperatives of art. The idea of realism for realism's sake was foreign to Dutch artists of the Golden Age, although verisimilitude was considered praiseworthy.

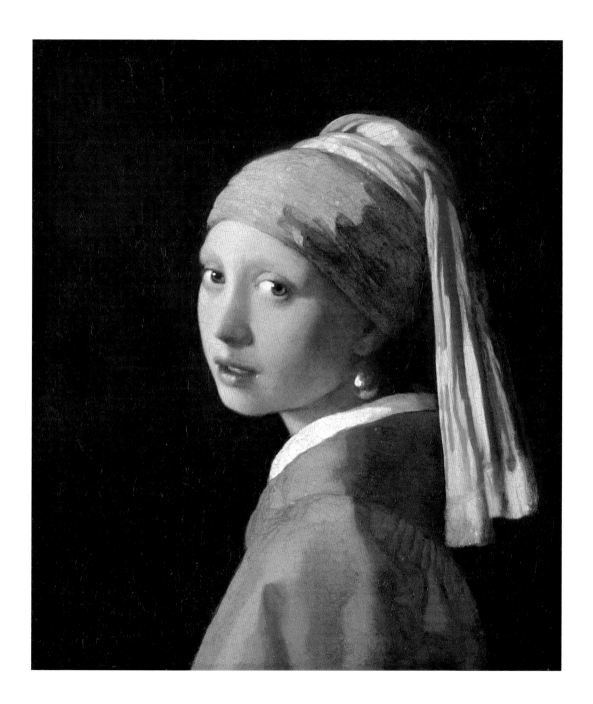

Girl with a Veil, c. 1664–67

Oil on canvas
44.5 × 40 cm
The Metropolitan Museum of Art, New York

One aspect that distinguishes Vermeer's achievement is that he was a painter of light in miniature. Rembrandt's late work can be called an exploration of light, with impressions sometimes coming to the fore, ahead of description; it falls into the category of the broad manner. No other artist up to Vermeer had been a painter of light (rather than of material) on such a small scale. The artist was prepared to set aside his knowledge of the physiognomy of a face to record light, regardless of how counter-intuitive the blurred shapes may have seemed. If light is depicted correctly then the mind organises impressions to fit mental constructions of volumes. In this painting, the face is built up through impressions, foregoing outlines.

Like the previous painting, an air of informality animates this *tronie*. Although the same size as *Girl with a Pearl Earring*, it is unlikely this contemporary painting was a pendant to it. *Tronien* were meant as standalone pictures to be kept in the artist's studio as tests and demonstration pieces. In painting these two portraits, Vermeer most likely wanted to show how he could provide a wide range of effects when dealing with the same subject and working to the same format. This may be one of the two *tronien* listed as "study of a head in Antique dress, uncommonly skilful" listed in an auction catalogue of 1696.

It has been suggested that the sitter for this painting is Maria, Vermeer's eldest daughter, respectfully named after her grandmother. There do seem to be facial similarities between her and the face of the drinker in *The Procuress* (page 47), which is supposed to be a self-portrait of the artist, her father. However, Maria was born around 1654 which would probably make her too young for this suggestion to be correct.

The secure provenance of this painting starts when it was sold and passed into the Dutch picture trade in 1812. It later entered an aristocratic collection in Belgium before reaching America in 1955 and eventually (by bequest) entering the Metropolitan Museum of Art, New York in 1979.

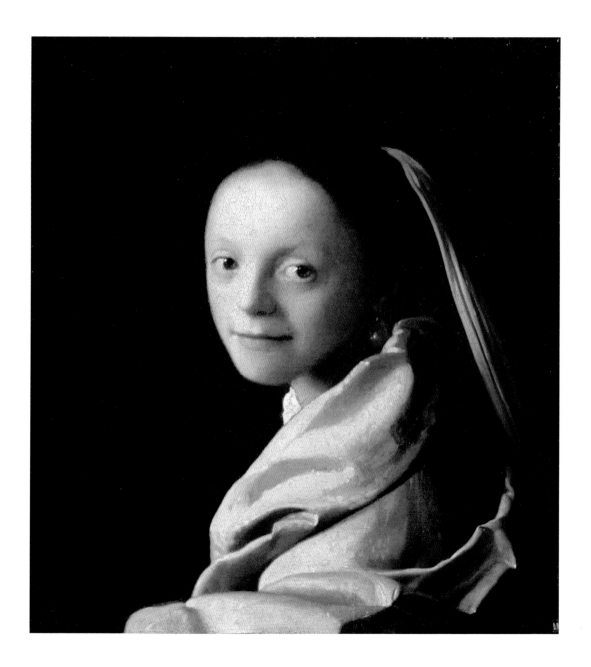

Girl with a Red Hat, c. 1664–67

Oil on panel
22.8 × 18 cm
National Gallery of Art, Washington D.C.

The startling red-feather hat is an exotic and flamboyant item, quite different from any other object in Vermeer's world. While this is the only such example in Vermeer's art, *tronien* often featured characters wearing antique, foreign or outlandish clothing, so at the time it was painted, this picture would not have appeared bizarre. Rembrandt collected props and curios for inclusion in paintings to such an extent that it contributed to his bankruptcy. Over long periods, Vermeer retained furniture, household objects and paintings for inclusion in his pictures; perhaps he even bought sculptures as props. A 1696 inventory lists a Vermeer painting, now tantalisingly lost: "A gentleman washing his hands in an interior with sculptures and a view through to a back room, skilful and rare."

Wheelock, noting that a loosely painted head of a man lies underneath the Vermeer painting, thinks that it is possible that Vermeer painted over a *tronie* by Fabritius. This is possible. Vermeer had owned two paintings by Fabritius and this "lost Fabritius" may have been another, perhaps unfinished. Fabritius was greatly esteemed and some of his art was destroyed in the explosion of 1654, so it is unlikely a completed Fabritius painting would have been overpainted by Vermeer.

Touches of red and terre verde enliven the sitter's face. Her appearance is similar to that of the *Girl with a Flute*, which adds to the case for that painting being an authentic Vermeer. On the other hand, historians have thought *Girl with a Red Hat* is not a true Vermeer because of the outlandishness of the hat, the unnaturally compressed space between the chair finials and the use of wood as a support. In my view, this painting is authentic and *Girl with a Flute* is not mainly or wholly a Vermeer.

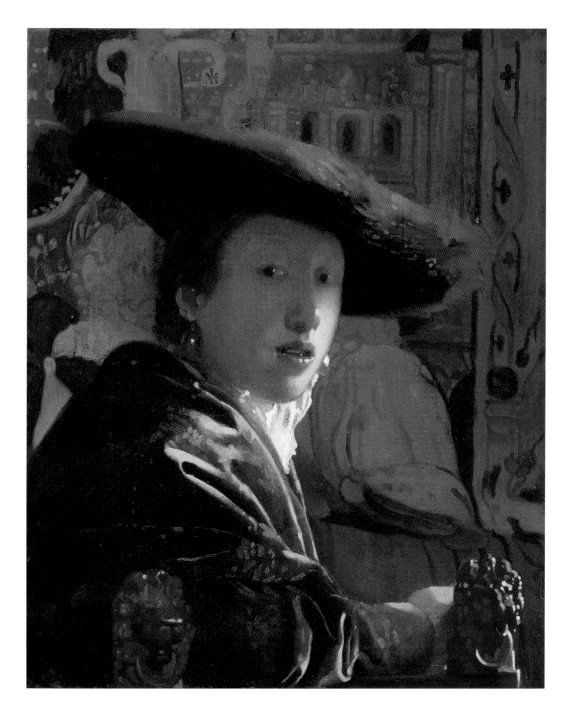

The Lacemaker, c. 1666–68

Oil on canvas
24.5 × 21 cm
Musée du Louvre, Paris

Portrayal of domestic work is widespread in Dutch pictures in the Golden Age. It had been a topic in Flemish painting of the previous century, when scenes of domestic servants in kitchens allowed artists to portray elaborate still-lifes alongside figures. In *The Lacemaker*, incidental detail is reduced to a stand, cushions, a few bobbins and some strands of thread. The book is likely a Bible or hymnal, reminding the audience that a pious life was an industrious one. This small painting has a powerful presence, not least due to the compression of figure and incidental detail at the centre of the picture. The handling of the threads and absence of incident in the background and foreground, drive our attention (mimicking the lacemaker's concentration) to the single point of where hidden hooks lace the thread.

The fact that the support for *The Lacemaker* is cut from the same roll of canvas used for *Young Woman Seated at a Virginal* (page 27, in my view, either completed or wholly executed posthumously by another hand) suggests a late date, perhaps as late as 1670, according to some historians. However, the descriptive care and detail suggest *The Lacemaker* comes from the late 1660s.

The degree of fading of the ultramarine pigment can be judged by comparing the rug near the book and where the rug reaches the edge of the painting, previously protected from ultraviolet light by the edge of the frame.

The Lacemaker and *The Art of Painting* (page 93) became particular obsessions for Salvador Dalí, who greatly admired Vermeer. He included Vermeer's figures in his Surrealist paintings. Although Vermeer was considered typical of seventeenth-century painting by Dalí and other modern artists, his treatment of paint was different from that of Dou, Mieris and others, called *fijnschilders* (fine-manner painters), who painted in a microscopically fine manner. Despite its small size, *The Lacemaker* is made up of daringly broad strokes of paint.

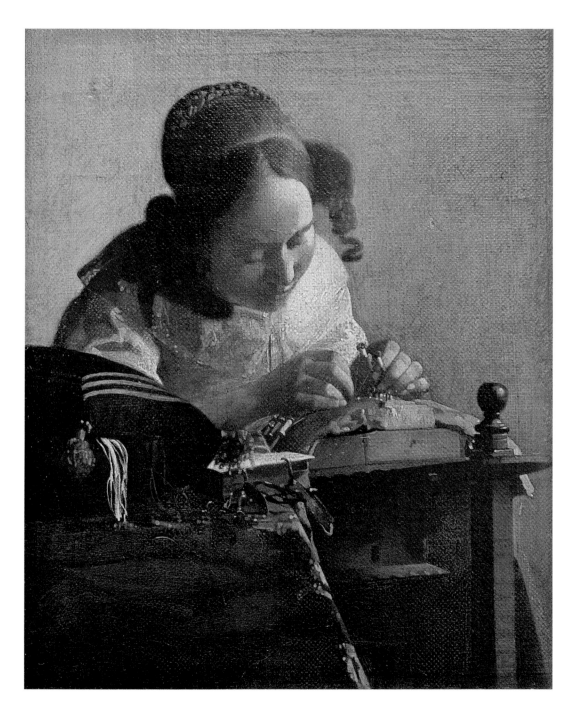

Mistress and Maid, c. 1666/67

Oil on canvas
90.2 × 78.7 cm
The Frick Collection, New York

Something that gives Dutch genre painting richness is its intellectual and emotional range, akin to theatre. Vermeer makes his scene a dramatic incident where anticipation and interaction are conveyed by essential but revealing gestures. Yet the meaning remains elusive. Vermeer has simplified the lady's raised hand so as to unify the line of arm, hand and face. Her thumb is reduced to a flattened shape, with only a little light shading and a faint crescent of nail. Her head has also been reduced in size slightly, exaggerating the foreshortening effect of its tilt. This modification shows that Vermeer was not bound to transcribe lens-derived outlines. Treatment of the lady's hair shows considerable abbreviation, with thin paint applied in a brisk manner, quite in contrast to the impasto and multiple layers in *Girl Reading a Letter at an Open Window*. Vermeer's skill is to suggest rather than describe, in the way that Velázquez had and Manet would.

The style and scene are closer to Maes than is usual for Vermeer. Description of the servant's face is conventional—ruddy in colour, volumetrically modelled, expressive—making it different from the floating forms of light that comprise faces in most mature Vermeer paintings. Due to the unusually smooth modelling and reduced detail of the exposed flesh, Schutz's late dating of 1666/67 is followed here. Another reason to date this painting late is the possibility that Vermeer had learned from the experience of painting his *tronien* of women's faces that isolating characters against a dark and neutral backdrop—as well as eliminating patterned areas—increases emotional intensity. This was a lesson Vermeer applied selectively in his last decade.

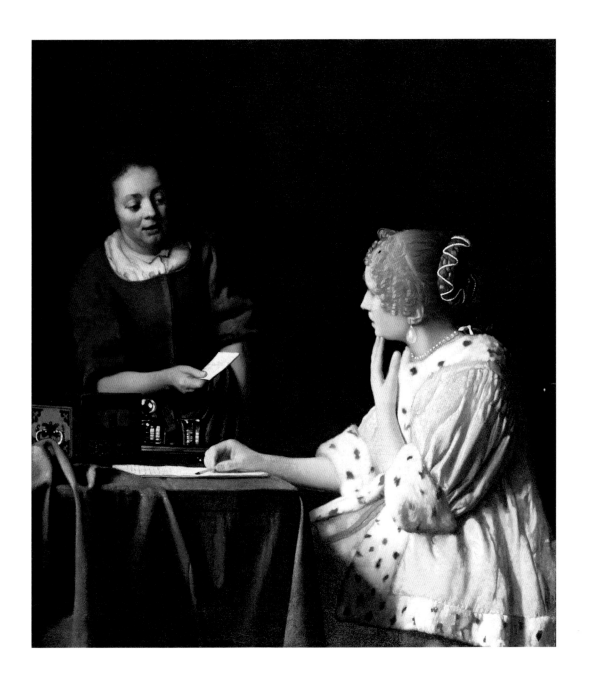

The Art of Painting, 1668? (or 1666)

Oil on canvas
120 × 100 cm
Kunsthistorisches Museum, Vienna

Considered a masterpiece that summarised Vermeer's brilliance and embodied
the nobility of art, *The Art of Painting* has exercised a magnetic hold over viewers
for centuries. Vermeer asserts painting's elevation from being a mere manual art
to being a noble liberal one, by favouring objects of contemplation over those of
labour. The artist is not an artisan but a gentleman dressed in a fine formal costume
and seated at his easel in an idealised studio. Rather than depicting the reality of
miscellaneous brushes, palettes, bottles, bags, tools, rulers and rags, Vermeer has
followed convention by depicting his artist in a space purified of the attributes of the
quotidian workshop. Whether this is an indirect self-portrait is an open question.
The female figure is Clio, Muse of History. In her hands she holds what is assumed to
be a volume of Greek history by Thucydides, considered the earliest master of that
liberal art. On her head she wears a laurel crown, indicating glory, and she carries
a trumpet, symbol of fame. On the table is a mask. The laurel wreath has turned
blue due to the fading of the yellow pigment in the original green. Vermeer placed
his signature on the map, close to Clio. Writers have debated why Vermeer chose
this particular map. It may be that, for the painting that he intended to be the most
important of his career, Vermeer simply chose the grandest map to which he had
access.
This painting has a signature and date, the latter of which has only recently been
discovered. Due to the degraded state of the date, it is impossible to determine
whether it reads "MDCLXVI" (1666) or "MDCLXVIII" (1668). Does this ambiguity about
the last two numerals indicate that the painting was considered complete in 1666
but then revised, with extra numerals added two years later?
Sometimes called "*Allegory of Painting*", Vermeer's family used the title the artist
had likely used himself: *de Schilderconst* (*The Art of Painting*). *The Art of Painting*
was kept by Vermeer as a demonstration of his skills and remained in his possession.
It belonged to his widow after his death until the family's debts compelled her to
sell it. The painting belonged to the Czernin family in Austria until it was sold in 1940
by Count Eugen Czernin and his brother to Adolf Hitler, who intended it to be the
centrepiece of a planned art museum in Linz. Ownership subsequently passed to
the Austrian state in 1945, then (in 1958) to the Kunsthistorisches Museum, Vienna.
Despite attempts by the Czernin family to reclaim the painting, courts have ruled
that the museum is the legitimate legal owner of this masterpiece.

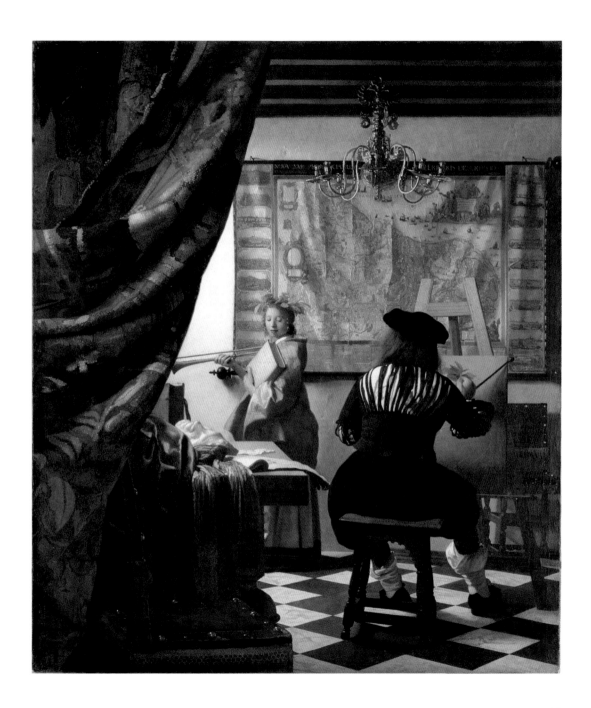

The Astronomer, 1668

Oil on canvas
51 × 45 cm
Musée du Louvre, Paris

There have been claims that the subject of this painting (and the following one)
is Antoni van Leeuwenhoek (1632–1723), scientist and resident of Delft, who is
commonly considered the inventor of the microscope. Van Leeuwenhoek was the
executor of the Vermeer estate and would have known the prominent painter's
achievements. They were born in Delft within a few days of each other. However,
there is no evidence of any specific relationship between the pair, other than the
posthumous legal one. Van Leeuwenhoek was appointed by the court to work on
behalf of creditors, not the Vermeer family. A surviving portrait of the scientist gives
a record of his appearance, leaving open the possibility that he is the subject of the
painting, aged about 36 years.

Depicted are then-modern versions of instruments of the ancient science of
astronomy: a celestial globe, astrolabe, brass dividers and a book that has been
identified (by James A. Welu) as the second edition of Adriaan Metius's *Institutiones
astronomicae et geographicae (Astronomical and Geographical Institutions
[Observations])* of 1621.

The window and horizontal frame of the globe, the astronomer's arm, shoulder and
the bottom of the frame comprise a striking horizontal line across the middle of the
composition. The vanishing point, where receding lines in the composition converge,
is precisely in the centre of the painting, namely, on the top of the astronomer's
sleeve, halfway between his face and wrist. The effect of this is to draw our attention
towards the centre, increasing our engagement and giving us a subconscious sense
of orderliness. The man's dynamic pose is a physical indication of his active intellect.

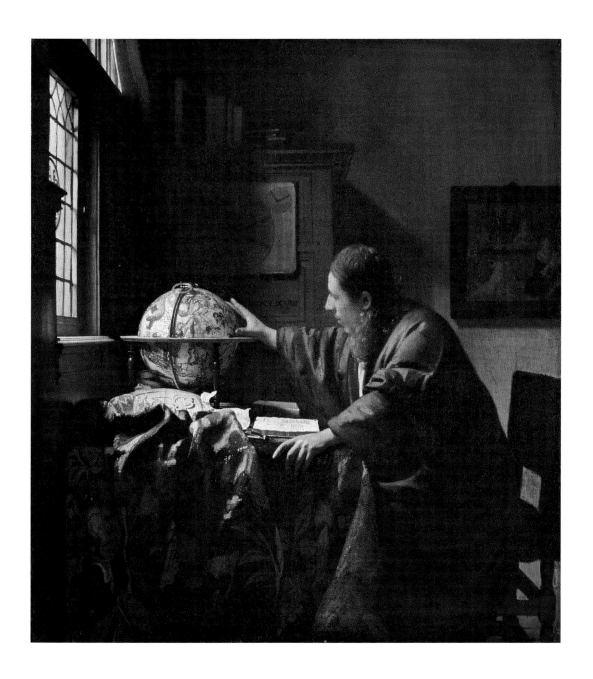

The Geographer, 1669

Oil on canvas
51.6 × 45.4 cm
Städel Museum, Frankfurt am Main

The geographer holds a pair of brass dividers, used to measure distances on charts, and gazes out of the window, lost in thought. His stance is active, indicative of the necessity of both contemplation and action for the mastery of knowledge. The geographer is clad in the same jacket as the astronomer, except the colours have been changed.

The Geographer and *The Astronomer* (previous page) are almost the same size and depict the same figure in the same room. Although the first one may have been painted as a standalone picture, the second painting (presumably *The Geographer*) was painted specifically to provide a pendant to the first. The pair were kept together for many years, only being separated in 1797. A date of MDCLXIIII (1669) has been added by someone later but this information is perhaps taken from a label on the original (lost) frame. Consequently, Wheelock dates the painting as around 1668/69. Examination has proved that the pieces of canvas for *The Geographer* and *The Astronomer* are cut from the same bolt of cloth, which confirms they were likely painted in close succession.

The terrestrial globe (published by Jodocus Hondius the Elder in 1618) is the same as that in *Allegory of the Catholic Faith* (page 107). Other objects are charts, books and a set square (on the chair); on the wall is a nautical chart of 1600. The papers on the table have been cleaned to excess, which has removed markings which might once have allowed for decryption.

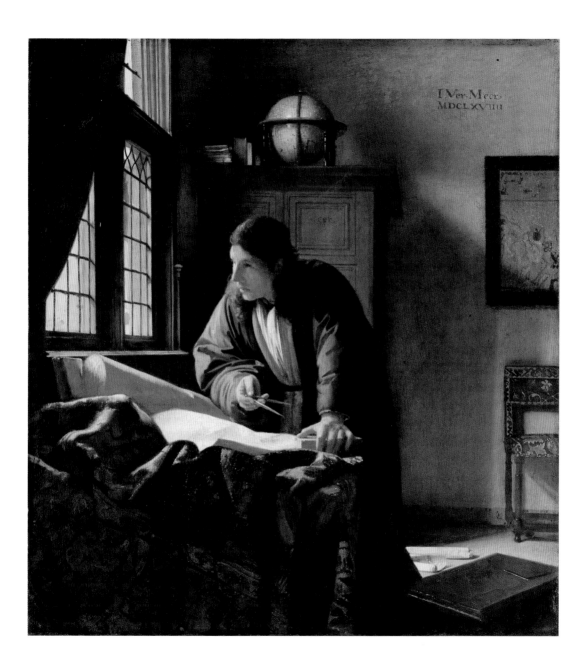

The Love Letter, c. 1669/70

Oil on canvas
44 × 38.5 cm
Rijksmuseum, Amsterdam

A maid delivers a letter to a seated lady, wearing a by now familiar yellow fur-trimmed jacket, with a cittern in her lap. The lady looks concerned but her servant does not and we infer from this that perhaps the latter is aware that there is good news in the letter awaiting the lady. In the background is a leather panel, embossed and partially gilded—a common (but costly) wall decoration of the era. In the foreground, so cropped and dim that it becomes almost illegible, is another map (the one that is shown in *Officer and Laughing Girl* (page 53) and *Woman in Blue Reading a Letter* (page 73)). The contrast between the respectable parlour and a dirty disordered anteroom suggests the theme of dark secrets and potential turmoil. Dark forms in the surrounding foreground work like a frame, directing the eye and heightening the concentrated drama at the illuminated centre. This style increases illusionism and gives us the sensation of looking into a dwelling place and spying on its inhabitants unaware. There was once a Vermeer painting of a man in a room with paintings and sculptures that had another room visible beyond. This is a tantalising idea to conjure with, as Vermeer tended to establish his spaces with very clear back walls and no facing windows or doorways "opening up" the back wall of the room. (*A Maid Asleep* (page 49) is the only exception.) *A Couple with a Parrot* (1668), a painting by de Hooch (now in the Wallraf-Richartz-Museum, Cologne), has been cited as a potential inspiration for this composition; it shows two figures seen through a doorway, with a leaning broom and curtain pulled aside in the foreground. *The Love Letter* is a title applied by others. Paintings were not usually titled until the advent of the salon exhibition in the eighteenth century; before fixed titles became expected, descriptions of subjects and sizes (and sometimes the name of a notable owner) sufficed to identify individual pictures. Aside from being confident that Vermeer's family called his studio scene "The Art of Painting", we do not know of any other titles used by the artist.

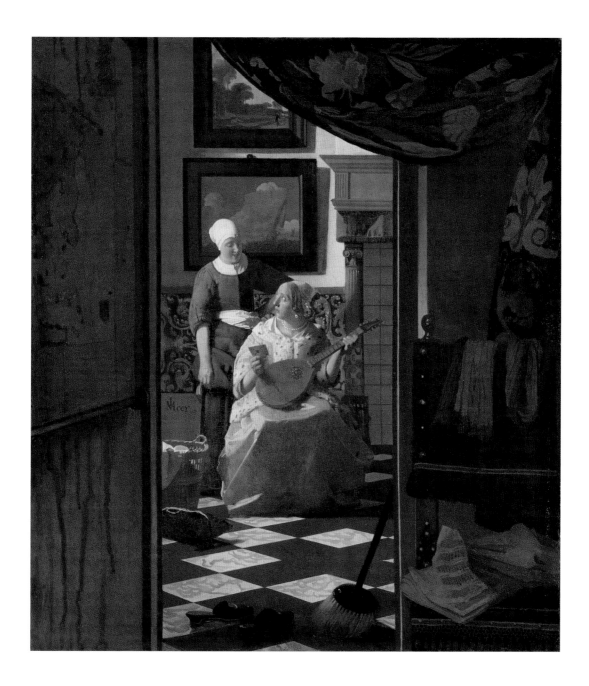

The Guitar Player, c. 1670–72

Oil on canvas
51.4 × 45 cm
Kenwood House, London

The Guitar Player, situated (nominally) in Vermeer's late period, is characterised by harshness in lighting, forms with less detail and modelling, increased tonal contrast and reduction in the number of objects depicted, with crisp edges replacing the sometimes-blurred outlines of former years. These stylistic choices generate greater drama and energy. Faces are less expressive and less subtle; in the case of *The Guitar Player*, the starkness of the dark hair and eyes against the pallid skin and light wall is striking, as is the pink blush of the cheeks. The gilded sound hole of the guitar and prominent striped decorative marquetry around the body and neck of the instrument display a delight in pattern making, almost detached from the task of realistic recording.

While the late style of Vermeer is acclaimed by some as a bravura finale of a master painter, it is understandable that others have reservations about the artist's late direction. The radical turn in Vermeer's approach can be seen in how reduced the range of tones are in the dress. Consider the technique for the necklace. In the earlier style, pearls are shown individually, each with shadows and highlights. In this painting, a necklace is made from a loosely painted graduated continuous band of pale grey with dotted highlights.

The cropping of the figure, its placement to the left of centre and the gaze of the woman out to the left seem startlingly modern. It is the type of unbalancing we find in Degas's deliberate strategies of making the viewer feel discomforted and thereby leading them to pay more attention as they attempt to locate the reason for their discomfort. Any suggestion that the painting has been cut down from its original size is contradicted by analysis of the canvas edges, which reveal the painting to be unaltered.

The signature is old but its lettering is irregular, deviating from Vermeer's careful writing. This suggests that this late work was in the studio in an unsigned condition in 1675 and that the signature was applied posthumously by someone else in order to authenticate the painting before it was sold. In that case, it may be that this is the last picture that Vermeer finished or nearly finished.

This painting was bequeathed by the Count of Iveagh to Kenwood House. In 1974, in separate thefts, supporters of the IRA stole *The Guitar Player* and *Woman Writing a Letter with her Maid* (page 105) to raise money for their cause through ransom. Both paintings were recovered within weeks. *The Guitar Player* was discovered in a graveyard in central London.

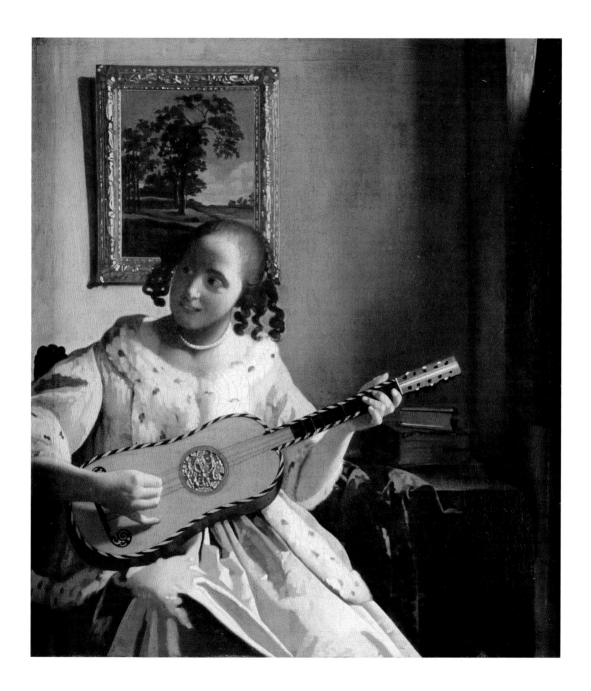

Young Woman Standing at a Virginal, c. 1670–72

Oil on canvas
51.7 × 45.2 cm
The National Gallery, London

Due to the realism of the treatment of the golden frame and the subtlety of the lighting of the figure, this painting may have been made before *The Guitar Player* (previous page), which shows a greater degree of abstraction and brevity. Nevertheless, most experts place this painting after *The Guitar Player*.
The picture is dominated by powerful verticals, which give it a stately imposing quality, as does its stillness. Here, near the conclusion of Vermeer's oeuvre, reappears the cupid of true love overcoming deceit, found in *Girl Reading a Letter at an Open Window* (page 51), painted when Vermeer first discovered his true calling. This work seems to be from a different era, even though it is less than two decades removed from the first. It feels like a picture that anticipates the future rather than responding to the past.
Despite the nearly identical clothing and a shared instrument—and possessing the same dimensions—this picture was likely made independently of *Young Woman Seated at a Virginal* (page 109), which seems to have been made later to accompany it. They were both in the same collection by the end of the seventeenth century.
The cool shadows of the face were produced using terre verde, which is unusual in depiction of skin at this time. When this pigment was used by others, it was applied as underpainting; Vermeer applies it here as the top layer. Painting cool-hued shadows of warm-hued forms would become common in the nineteenth century, especially among the Impressionists.

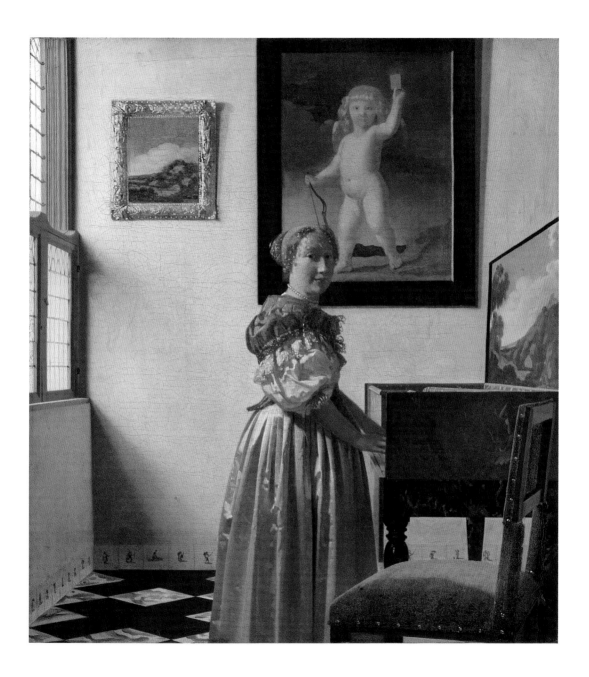

Woman Writing a Letter with her Maid, c. 1670–72

Oil on canvas
71.1 × 60.5 cm
National Gallery of Ireland, Dublin

A lady writes a letter as her servant looks out of a window, awaiting the errand of delivering that letter when complete. On the floor are an opened letter, a detached wax seal and a stick of sealing wax, which have fallen (or been cast aside) to the floor in an act of carelessness or temper. Envelopes were not common in this period. Letters were folded up, the name of the addressee added outside and then the letter sealed with a dab of wax, applied as melted liquid and impressed with a metal seal. One interpretation is that the letter on the floor was cast aside by the lady of the house; she now writes her reply. Another reading is that the writer discarded a first letter and has now suitably composed herself to write again. Lost in her thoughts, she ignores the maid, who in her turn retreats to her interior world. We are invited to consider what that maid is thinking about and if her cares are so different or less important than the matter preoccupying her mistress.

The picture on the back wall depicts the finding of Moses. The Dutch identified with the Israelites because both peoples fulfilled divine providence after overcoming enemies in order to establish their homelands. Writers have disagreed over what the association is between that subject and these two women.

Notice the radical simplification of the lady's sleeves, rendered as discrete patches, very different from the graduated blending of the late 1650s and the 1660s. The uninflected folds of the maid's skirt are typical of the late style of Vermeer.

It seems this late painting was in possession of the artist at the time of his death and was used by his widow in 1676 (possibly alongside *The Guitar Player*, page 101) as payment of a debt to the baker van Buyten.

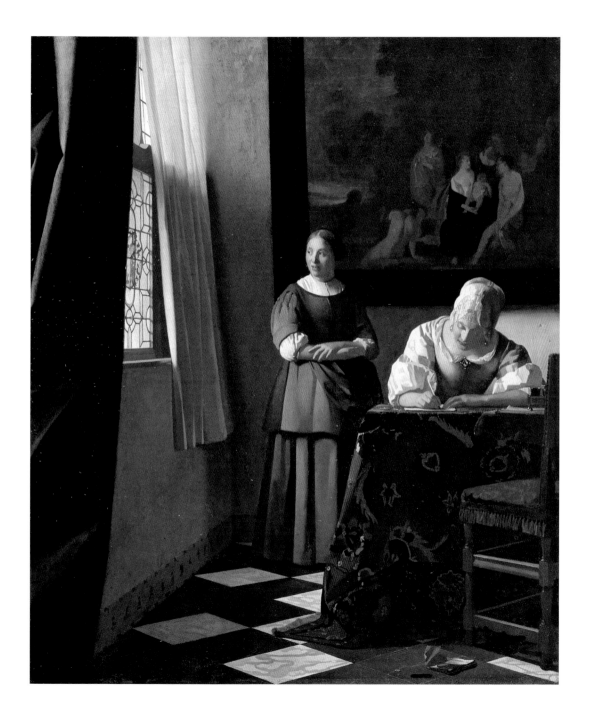

Allegory of the Catholic Faith, c. 1670–74

Oil on canvas
114.3 × 88.9 cm
The Metropolitan Museum of Art, New York

This is an allegory of the principles and supremacy of the Roman Catholic faith, symbolised by a woman in white and blue who has her foot on a terrestrial globe, hand on heart and gazes toward a suspended glass globe (the immaterial world of the spirit). These symbols follow those outlined by Cesare Ripa in his manual *Iconologia* (1593). The apple stands for the sin introduced to mankind by the serpent of evil, which is here smitten by a cornerstone, in turn symbolic of the Catholic Church, founded by Saint Peter, Christ's "rock". An altar supports a crucifix (liturgy) and a chalice (the sacraments), both rejected by Protestantism, as well as an open Bible. The painted crucifixion behind demonstrates the example of Christ's suffering and the salvation promised to the faithful. The painting, *The Crucifixion of Christ* (page 36), is by Jacques Jordaens, which Vermeer simplified to prevent it from distracting the viewer, something common to his practice when including other artist's paintings.

The blue cushion and ceiling beams are painted in an uninflected way, emphasising abstract pattern rather than realist play of light over material. Realism is antithetical to allegory, as it undercuts and contradicts the power of symbolic demonstration of eternal verities. Allegory relies upon universal qualities; realism depends upon specificity. The treatment of the tapestry, where a figure leads a horse (perhaps derived from a painting by Rubens), unknowingly presages the pointillism and extreme stylisation of Georges Seurat (1859–1891).

This painting is unusually explicit in its allegorical contents, which has led some commentators to suggest that it was made during the *rampjaar*. Struggling to make sales during this time, Vermeer felt perhaps compelled to take up a commission that was alien to his temperament. So odd does the painting look to modern eyes, that Binstock suggests the painting is parodic and reveals resentment towards Catholic symbolism. Whatever the cause, Vermeer seems to have painted less in his last years; notwithstanding the possibility of paintings being lost, the evidence is that his production rate slowed after 1671. Was this because of the death of his patron Pieter Claesz. van Ruijven in 1674, the reduced market for art in the *rampjaar* or possibly due to the illness or debility of the artist? The ultimate cause (or causes) are open to debate.

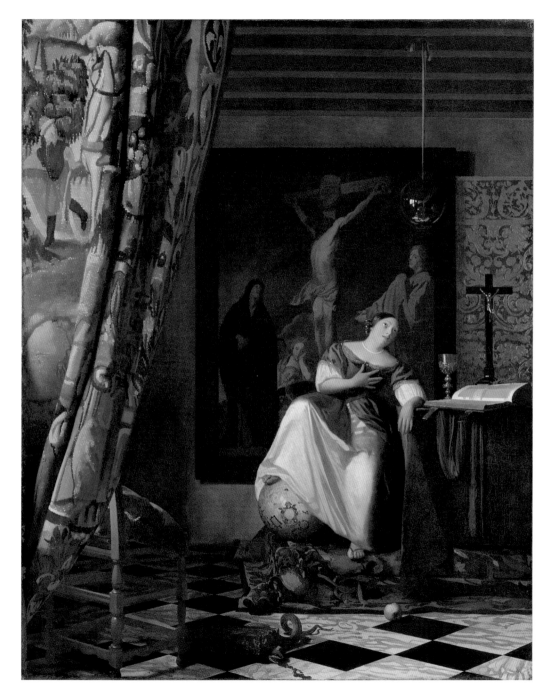

Young Woman Seated at a Virginal, c. 1672–75

Oil on canvas
51.5 × 45.5 cm
The National Gallery, London

This painting, once owned by Thoré-Bürger, is not thought by experts to be a pendant to *Young Woman Standing at a Virginal* (page 103). Most likely made later, this painting differs stylistically from the earlier one. The folds of the dress are abstracted rather than following observation. This is so obvious that it almost suggests that Vermeer was engaging in the Baroque practice of elaboration to draw attention to the artificiality of painting. The marbling on the wooden panels of the instrument are blatantly artificial and contrived; it is as if Vermeer is inviting us to consider how fine-art painting is a variant of the illusionism of decorative painting. The model in this painting seems younger than her counterpart.

The blue of the dress has been produced by adding terre verde to ultramarine. The dilution of ultramarine may not have been solely a matter of aesthetics. Vermeer may have been aiming to extend the small amount of the expensive pigment. Analysis shows that he used older, worn-out brushes in his last years. Vermeer elsewhere adjusted anatomy for the sake of pictorial harmony. Here the painter (perhaps) goes too far. When looked at carefully, the hands and wrists of the lady are distractingly simplified.

When we think of Vermeer in comparison to great artists who died prematurely—Masaccio, Giorgione, Raphael, Pieter Bruegel the Elder, Schiele—we are left with a number of questions. Those artists were at the peak of their power and originality; what could they have achieved had they lived and how might those achievements have altered the path of art history? Notwithstanding the love and admiration we have for Vermeer's remarkable visions, should Vermeer be situated with them or should he be classed as an artist already in decline by the time of his demise, aged 43? Just as the nature of the artist's apprenticeship and travels is unknown, so too are the artistic intentions of Vermeer's last years and what (if any) paths he may have wished to pursue in coming years. Speculation about Vermeer's potential artistic direction at the time of his death in 1675 leaves us as puzzled by his end as we are by the obscure origins of this remarkable artist.

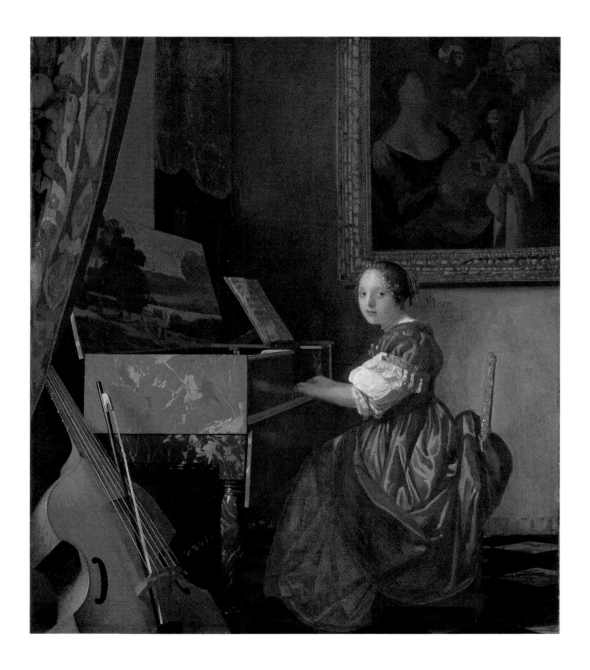

FURTHER READING

Bailey, Martin, *Vermeer*, London, 1995

Banconi, Piero, *The Complete Paintings of Vermeer*, New York, 1967

Binstock, Benjamin, *Vermeer's Family Secrets: Genius, Discovery, and the Unknown Apprentice*, London, 2013

Duparc, Frederik J., and Wheelock, Arthur K. (eds.), *Johannes Vermeer*, New Haven/Washington DC/The Hague, 1995

Landsman, Rozemarijn, *Vermeer's Maps*, New York, 2022

Liedtke, Walter (ed.), *Vermeer and the Delft School*, London/New York, 2001

Montias, John Michael, *Vermeer and His Milieu: A Web of Social History*, Princeton, 1989

Roelofs, Pieter, and Weber Gregor J.M. (eds.), *Vermeer*, Amsterdam, 2023

Schama, Simon, *The Embarrassment of Riches: An Interpretation of Dutch Culture in the Golden Age*, London, 1988

Schutz, Karl, *Vermeer: The Complete Works*, Munich, 2015/2021

Weber, Gregor J.M., *Johannes Vermeer: Faith, Light and Reflection*, Amsterdam, 2023

Wheelock, Arthur K., *Vermeer*, New York, 1997

Wheelock, Arthur K., *Vermeer and the Art of Painting*, New Haven, 1995

Wolf, Norbert, *The Golden Age of Dutch and Flemish Painting*, Munich, 2019

PHOTO CREDITS